The Last Farewell

Julie Whitman Jones

Thomas

The Last Farewell

Edmund Burke O'Connell
Co-authored by Julie Whitman Jones
and Thomas J. Sullivan, Jr.

Copyright © 2006 by Edmund Burke O'Connell, Thomas J. Sullivan, Jr., and Julie Whitman Jones.

Library of Congress Control Number:		2006909749
ISBN 10:	Hardcover	1-4257-4187-8
	Softcover	1-4257-4186-X
ISBN 13:	Hardcover	978-1-4257-4187-7
	Softcover	978-1-4257-4186-0

All rights reserved. No part of this book may be reproduced or transmitted in any form or by any means, electronic or mechanical, including photocopying, recording, or by any information storage and retrieval system, without permission in writing from the copyright owner.

This book was printed in the United States of America.

To order additional copies of this book, contact:
Xlibris Corporation
1-888-795-4274
www.Xlibris.com
Orders@Xlibris.com

Contents

Foreward ... 9
Author's Note .. 11
Acknowledgements .. 13
Prologue ... 15

Chapter 1 Florence is now free ... 19
Chapter 2 A beautiful stranger ... 33
Chapter 3 Lights, camera, action! .. 43
Chapter 4 You're in the Army Now! 47
Chapter 5 "Colonel Vosbergh" was here 62
Chapter 6 Rebirth of the Villa Calamai 70
Chapter 7 A special photo assignment 82
Chapter 8 Premonition .. 85
Chapter 9 Digging in—Fall 1944 ... 93
Chapter 10 Thanksgiving, 1944 ... 108
Chapter 11 Life along the front lines 116
Chapter 12 Merry Christmas, Gatto 122
Chapter 13 Reassignment ... 125
Chapter 14 Battle for Bologna .. 129
Chapter 15 Sightseeing in scenic Venice 147
Chapter 16 A race to the Alps .. 151
Chapter 17 Return to Merano ... 156
Chapter 18 War's end .. 164
Chapter 19 Garrison duty in Verona 173
Chapter 20 "Heaven's to Hemorrhoids" 190
Chapter 21 A reunion with Tina ... 192
Chapter 22 Tales of the "Blue Cat" 195
Chapter 23 Axis Sally leaves the airwaves 198
Chapter 24 Return to Florence .. 201
Chapter 25 A summer picnic to remember 212
Chapter 26 A birthday date .. 215
Chapter 27 Angels working overtime 219
Chapter 28 Fate's Folly ... 223
Chapter 29 "That's it, kid" .. 227

Epilogue: Coming home to Italy at last 231
Afterword .. 235
Notes ... 249
Origins of the 196th Signal Photo Company 251
Bibliography ... 274

Dedication

To Burke and Tina, with love.

Foreward

Publication of **The Last Farewell** honors a promise I made to my late stepfather, Edmund Burke O'Connell to help him share his very special love story.

I owe special gratitude to my true love and writing partner, Thomas J. Sullivan, Jr., who entered my life and my own heart, recognized a great story, and shared with me his enthusiasm to bring this project to life.

I would also like to acknowledge my mother, Jan, for introducing Burke into the young lives of my brother Jeff and I when she married him in 1972.

To a wonderful man, to the stepfather who became a friend, I dedicate this book to you, Burke.

—*Julie Whitman Jones*

Author's Note

Edmund Burke O'Connell began typing the first pages of ***The Last Farewell*** in 1975, thirty years after the end of the Second World War in Santa Monica, California when he was 61 years old.

Co-authors, Julie Whitman Jones and Thomas J. Sullivan, Jr. add relevant historical detail O'Connell did not have ready access to at the time of his manuscript's original creation.

Materials include official U.S. Army accounts of the Italian campaign, organizational unit histories of the 3131st Signal Service Company and the 196th Signal Photo Company, personal interviews and web research.

The primary focus of ***The Last Farewell*** recalls the origins of Burke's unexpected romantic relationship with Tina Calamai, an attractive, then-married Florentine woman he met during the Allied liberation of her city during the summer of 1944.

Indirectly, the completion of his memoir may have fulfilled a personal promise Burke made to himself to say a final farewell to the post-war Italy he could never return to, and to honor Tina's memory and all he cherished dearly of her.

The Last Farewell is a tribute to all who served in the Italian campaign of World War II and in recognition of the work of those front-line still and motion picture combat photographers who brought home, and continue to capture for the American home front the violence of modern war.

Acknowledgements

The author(s) wish to especially acknowledge the generous help of former Army still photographer, Donald Wiedenmayer, 89, a surviving member of the 3131st Signal Service Company and the 196th Signal Photo Company who generously contributed remembrances, photos, and historical detail concerning his service in the unit and of his friendship with his partner, newsreel photographer Burke O'Connell with whom he worked with until the end of the war in May 1945.

Complete military unit histories of the 3131st Signal Service Company and the 196th Signal Photo Company obtained from the National Archives help to establish a supporting historical timeline to O'Connell's unique wartime story.

The authors also wish to thank:

- Daniel Brown, historian/archivist, U.S. Army Signal Center, Fort Gordon, Georgia.
- Melissa Ziobro, Command Historian, Fort Monmouth, New Jersey.
- Jenifer Stepp, Stars and Stripes.
- Peter Maslowski, PhD, author, **Armed with Cameras: The American Military Photographers of World War II** (1993) University of Nebraska, Lincoln.
- Gloria A. Mote, Director, Los Angeles National Cemetery.
- Mitchell A. Yockelson, National Archives, Modern Military Records, Textual Archives Services Division.
- Jane Johnson, Public Library of Charlotte and Mecklenburg County, North Carolina, for use of the obituary of Army photographer Harry B. Morgan reprinted with permission from the *Charlotte Observer*, December 5, 1944.
- Naleen Butler, Cemetery Services Specialist, City of Mesa, Arizona, Cemetery for photographs of the gravesite of Cecil Max Campbell.

Selected Army Signal Corps photos are credited by full name to individual still photographers of the 3131st Signal Service Company and the 196th Signal Photo Company where possible or to the National Archives where specific photo credit is not known.

Prologue

Man can often find himself in the most curious situations, having arrived therein by the most natural means. Yet, at the same time, he is stupefied as to how it all happened. It was that way with me that I, a 30-year-old enlisted Army Signal Corps combat photographer would unexpectedly find myself living in a 15th century historic Medici villa in the Tuscan countryside north of the city of Florence, Italy in the midst of war all around me and unexpectedly falling in love with the attractive daughter of its owner.

The story of our unfolding love affair, which began in the summer of 1944, was for each of us, the progression of an incredible chain of events. The love we shared for one another became the most natural experience in the world that two lucky people could ever share.

I used the viewfinder of my Bell and Howell Eyemo 35 mm motion picture camera in a modest way to help show and then tell the story of the Fifth Army's heroic "March to the Alps" to the folks back home. The Eyemo's small size and ruggedness made it a favorite choice for newsreel and combat cameramen covering both theaters of the war.

The Italian campaign was a long, brutal mountainous walk from start to finish. By the time the Italian campaign had ended in early May 1945, my own well-worn combat boots, like so many others, walked from the hot desert sands of Oran, Algeria in 1942, into the streets of Naples, through historic Florence, and up and down the endless rugged Apennine mountains of Italy where mules struggled to go, across the Po Valley to the German Army's final capitulation in the foothills of the Alps in May 1945.

Army still and motion picture cameramen of the 3131st Signal Service Battalion and the redesignated 196th Signal Photo Company who were assigned to the U.S. Fifth Army created an important historical record of its final drive to the Alps where it crushed the last elements of stubborn German resistance in Italy.

In our last days of the war, we linked up in celebration with fellow photographers of the 163rd Signal Photo Company of the U.S. Seventh Army which drove towards the German heartland from Southern France to join hands across the Brenner Pass in the Alps.

The center drawer of my desk in the den in my Santa Monica, California home was still chock full of all sorts of official military papers, important or not, and personal souvenirs of my wartime combat experiences from thirty years before.

You could say I am no different than anyone else when it comes to wanting to create "a place for everything and to put everything in its place."

Unfortunately, I rarely succeeded. I think only mechanics whose tools manage to hang neatly before their eyes ever really accomplish such correctness. I never could.

Inside my desk were a collection of old 8 x 10, black and white U.S. Army Signal Corps photographs I'd taken, my original Army discharge papers, a Walther pistol I had confiscated from a clever German officer who tried to ease past me in the Po Valley north of the city of Venice; and a copy of a regimental Croix de Guerre citation for heroism in combat that French General Alphonse Juin had proudly awarded me, probably because in some way I must have succeeded in keeping his French soldiers looking French, in spite of our G.I.-issued olive-drab combat fatigue uniforms, our food and our post exchange (PX) supplies.

Juin commanded the French Expeditionary Corps in the U.S. Fifth Army during the Italian Campaign.

Almost every time I would open my desk drawer to look at the disorganized mess inside, an Army letter of commendation citation would teasingly roll up deep in back out of my reach and would unroll when I closed it. This citation, dated August 1944, was given to me by Major General Geoffrey Keyes of the U.S. Army II Corps.

The US II Corps was the first American formation of any size to see combat in Europe or Africa during World War II. The II Corps fought its way up the western side of Italy, ending up on the right flank of U.S. Fifth Army in May 1945.

I recognized that I had begun to make a mess of the citation, and the only real solution would be to take the coiled fading paper from my desk and have it properly framed since it still had sentimental value to me.

Most people who have ever served in the military tend to treasure their wartime memories, which provide a valuable, lasting anchor to our youth.

I had developed a warm friendship with Heinz Himmelman, the owner of an art and framing shop not far from where I now live in Santa Monica, California.

Heinz had immigrated to the United States not long after the end of the Second World War and was also in his early 60s as I was.

Since oil painting is one of my favorite hobbies, I had become fast friends with Heinz who came to frame quite a lot of my finished works.

Heinz could always tell in what esteem I held a newly-completed oil painting of mine by the price and quality of the frame he would consider proposing to put around it.

On the day I handed Heinz my wrinkled Army military commendation for his professional consideration, he immediately selected a higher-priced wood and gold frame he thought I might prefer. I modestly told Heinz that the choice of frame was not a question of money, but I did not want to make a public monument out of my long-ago wartime efforts.

I offered my opinion to Heinz that a simple frame which might serve a common high school diploma or even a Bar Mitzvah certificate would serve the purpose equally well.

He nodded in recognition of my concerns, but began reading the citation out loud in a still-precise German accent.

> *"Sergeant Burke O'Connell is hereby commended for the heroic achievement in support of combat operations in Italy, August 15, 1944. O'Connell, assigned to the 3131st Signal Service Company, of his own volition, crossed the Arno River into the northern section of the city of Florence, Italy with a combat patrol of the British Eighth Army . . ."*

My mind soon drifted back from the present (1975) into a still-familiar period of my life now some thirty years ago to the wartime city of Florence, Italy as Heinz continued to read. I was once again an American soldier standing proudly at attention before a formation in front of my fellow soldiers wondering nervously under my breath what the sudden fuss and formal recognition of my actions I was about to receive from my Army superiors was all about.

> *". . . and with complete disregard for his own safety he exposed himself to enemy machine gun fire and obtained for the War Department a complete and vivid picture of the mission,*
> *Signed, Geoffrey Keyes, Major General, U.S. Army."*

My attention as I listened to Heinz was far, far away when Heinz abruptly snapped me back to the present when he said to me in recognition of such a measure of personal heroism, my wartime citation clearly deserved, in his opinion, a more appropriate picture frame.

I looked back at the battered paper Heinz now held in his hands. It had been so many years that I had heard the precise words of the actual citation again read aloud to me, those thoughts of that single day, but deeper memories of the war now came alive.

No longer did I hear just familiar words and sounds. The little combat soldiers printed on the paper before me seemed to do more than just move about. They were shooting, ducking for cover and falling wounded in battle. I followed their movement through the imaginary viewfinder of a camera I again held in my hand.

Once again, I heard the crackle of rifle fire and felt the explosive impact of artillery shells falling near.

Beads of sweat began to steadily trickle down my face, just as they had the morning of August 15, 1944 in Florence, Italy when I anxiously looked across the banks of the Arno River with that British infantry patrol where we would cross and again heard the familiar sounds of rifle fire crackling ever closer around me.

Chapter 1

Florence is now free

August 1944, Florence, Italy

By late July 23, 1944, the U.S. Fifth Army, led by General Mark Clark, was poised along the south bank of the Arno River on a 35-mile front extending from the sea to the Elsa River, twenty miles to the west of the city of Florence. During the previous six weeks, soldiers of the Fifth Army had steadily driven through the ripening, Italian grain fields and vineyard-clad hills of central Italy towards the Arno River.

General Clark decided against crossing the Arno River in favor of pausing to rest and reorganize his troops and assemble supplies. Liberation of the historic, treasured city of Florence, Italy, fell to forces of the British Eighth Army.

Burke served as a still photographer in the 3131st Signal Service Company when he first reported for duty at AFHQ in North Africa and his primary duties were those of a motion picture newsreel photographer once in Italy.

He and his first partner, still photographer, John T. Mason, whom he affectionately nicknamed, "Honest John" were already seasoned combat veterans of the North Africa, Sicily and Salerno campaigns where they were assigned together as a two-man photo team to cover one of the first infantry reconnaissance patrols of the British Eighth Army which was moving from the outskirts of the historic city of Florence, Italy into its center.

John Mason and I found ourselves fortunate to be tasked by our superiors to cover the combat operations of the British Eighth Army late in July 1944. Our British allies had successfully pushed back stubborn German resistance and now occupied a considerable portion of the historic city of Florence south of the Arno River by August 4. They would complete

the demanding work of taking the remainder of the Arno River line from enemy control later that same week.

In an account of the Italian Campaign written after the war, German Field Marshal Albert Kesselring who commanded the bulk of enemy forces throughout the Allied campaign in Italy had said he had never realized what it was like to wage war in a museum until he came to Italy.

The Germans declared Florence an "open city," and angered by the withdrawal of Italy from the war, took their pick of transportable paintings and sculptures as they strategically retreated north to their next critical line of defense, the Gothic Line.

Certain cities such as Florence, Paris and Rome are considered such international treasures that are considered by many not to belong to any one people.

Their exceptional beauty and splendid art treasures ought to be shared with everyone throughout the world. A decision by the Germans to vigorously defend either city from liberation by the Allies could have meant total destruction of one of the true jewels of the world.

Both the cities of Florence and Rome received special treatment from both sides for their historic value, but such public declarations can also prove to be dangerous since the decision gave armed residents of both cities an open license to settle past grievances with uncontrolled violence and unnecessary public bloodshed.

The Allies quickly had to restore order in both cities to prevent a broader civil war from breaking out.

The Germans conveniently blew up nearly all of the essential bridges in Florence, except for the Ponte Vecchio which had been described as one of Hitler's personal favorites. Historic medieval homes on both ends of the Ponte Vecchio were strategically destroyed, blocking any form of vehicle traffic across the bridge.

The Arno River divides the city of Florence in the middle. The Germans had strategically blown all the bridges up in the city except the Ponte Vecchio making our situation, especially for heavy equipment, including tanks and trucks, a serious problem.

Field Marshal Kesselring needed time to retreat into his prepared Gothic Line in the Apennine Mountains. While the Italian fascists were staging a sort of civil war with the partisans in the cities, it would be impossible for the Allies to take command and restore order without getting involved.

The main route of the U.S. Fifth Army through Florence was also decisively blocked until combat engineers could put temporary Bailey Bridges across.

Nearly every Italian city, town and hamlet was crowded with some form of precious religious and historical treasures, medieval monasteries, frescoes,

statues, churches, Roman bridges and aqueducts, Baroque fountains and Renaissance paintings. While Italy would rebound from the devastation of the war in the years to follow, numerous treasures sadly would not.

It was against this backdrop that American still and motion picture combat photographers sought to document the military history of the Allied Italian Campaign.

American combat photojournalists typically traveled in a team of three soldiers. One was assigned the role of still photographer, the second took motion pictures and the third soldier served as a primary driver for the jeep and trailer. My partner, John Mason and I took turns in the field taking still and motion pictures as combat operations dictated.

Mason was born in Detroit, Michigan, and tended to call himself, for his own reasons, "Honest John Mason."

John and I were first paired together during the North African campaign and had formed a close, personal bond of real trust and friendship between us.

Our driver during this assignment was a young soldier named James "Snuffy" Owens who I now recall was born in the rural hills of North Carolina. "Snuffy" could best be described as "thin as he was tall, with straight light brown hair as fair as an oat field ready to be cut."

Owens could be described was a good-natured kid, and his hayseed sense of humor gave John and I more than a few much-needed laughs.

He had a slight aversion at being shot at, as we all did, and preferred to stay behind and guard our equipment trailer when given a first choice.

Soldiers of the British 6th Armoured Division and the 6th South African Armored Division had by mid-July 1944 continued their drive up the Arno River from the south on a broad front northwest of the city of Arezzo.

The British could have been forced to halt without entering Florence in strength, except on July 17th, the 6th South African Armored Division had gained control of a key ridge of the nearby Chianti Hills, and from this important high ground, the South Africans could direct flanking fire against the Germans driving them from the city to allow British armor to cross the Arno in strength.

The absence of significant organized German resistance within the city of Florence made its liberation easier for the British.

John and I were soon graced with a walk-in entry to Italy's famous historic cultural and artistic center and would later discover Florentines paving the streets before us with flowers.

The British allies, with their usual flair for the dramatic, decided to send a small scouting patrol across the river this August afternoon to feel out the situation on the other side.

John Mason and I were invited to join this Allied patrol and tasked to take pictures useful for military intelligence.

This initial British infantry scouting patrol to which we were assigned was expected to draw some measure of small arms fire from possibly the Italian fascists in the buildings directly across the river or from well-concealed German snipers on the roofs.

If the German occupiers joined in the fight, then our decision to cross would be obvious and a larger Allied force would fight in strength.

We wondered whether bands of armed Italian fascists would hold their fire and play a cautious waiting game when we crossed. The British scouting patrol would call their bluff if they intended to shoot us, and if they didn't would move quickly to secure the historical center of the city with the goal of making vehicular bridgeheads then possible.

So, it was on a Sunday morning on August 15, 1944, that Honest John Mason and I walked into a British regimental command post (CP) alongside the Arno River watching a battle plan unfold. We were the only two Yanks in the room.

The British commander, a typical ramrod type, outlined the task to the Allied patrol that gathered around him.

"Now lads," the British major began, "it might get a bit sticky but keep it steady. Fire only if you are fired on. Got that, Lieutenant?"

A boyish lieutenant with a large overbite and brown wavy hair that clearly had a difficult time staying under his overseas beret clicked his heels and gave an affirmative bark to the officer in charge.

"You will cross the Arno River down there at the weir," the British major crisply instructed.

I learned that the weir he pointed to on the map signified a sloping earthen and stone berm that marked the river banks lining both sides through the center of the city. We were also fortunate to discover that the crossing would take place in relatively shallow water.

"That means you will have to climb the wall on this side and on the other as well.

"Now, if they're any Italian black shirts about, you'll be sitting ducks, so you'll have to get along with it. Understand?"

There were plenty of Italians who identified with the infamous black shirts who put Dictator Benito Mussolini in power in the first place still shooting at Allied troops.

There didn't seem to be any confusion concerning the urgency of the combat operation.

"If you are successful, then Jerry will know we mean business and we can start moving troops across."

The Brits always seemed to refer to their German opponents as "Jerry." The Americans had less polite names for their common enemy.

The operation sounded simple enough.

The briefing ended and the British commander surveying the scene looked at us standing idly by, out of place as two Americans generally do in a group of twenty Englishmen.

"Are you the photo types that are going along to take pictures?"

We assured him that we were.

"Well, get a good shot of the Palazzo Vecchio. It's a great English bit of sightseeing."

Our patrol started moving down the shady street along the river and moved into bright summer sunlight and enemy range.

The walk in the summer sun would be on the other side where everything glistened and sparkled so that a gun sight could pick it up 500 yards away. Infantrymen always hated a walk in the sun. There had been many and there would be many more before this brutal war would be done.

Rifle and machine gun fire chattered on both sides of the river. In the distance, chips of the old buildings could be seen exploding into dust. You had the uneasy feeling in your gut that the enemy could see down deep inside your stomach, and the butterflies seemed to be lining up to go out with the attack of diarrhea that now seemed imminent.

We got to the weir. John and I were about in the middle, which is the ideal place, if you have to be there in the first place.

Johnny went over the wall first. I handed him down our equipment, a Speed Graphic still camera, and my Bell & Howell 35-mm motion picture camera. I also carefully handed down to John two canvas gas mask covers full of film. We discovered about three inches of water easing over the weir which was just enough to get your shoes wet and cause you to slip on the slime and fall.

John and I went carefully down the bank of the Arno River on foot and moved towards the opposite side. We soon discovered just how difficult it was to tell who was shooting at whom. Random bullets fired from the opposite side of the river could quickly get you killed.

The first members of our patrol had made it successfully over the wall when John and I came up to it. There was a large burst of gunfire that sounded like it came from the rooftops in our direction.

I didn't turn around to see who it was, but some of our guys were firing from the south side and hitting the wall ahead of us.

It's nice to know that someone is trying to provide cover for you in a spot like this but the thought always hits you as to when will they stop firing.

We wasted no time and quickly climbed up the wall to make our crossing. We heard even more gunfire down the street. The broad cobblestone street we

came upon, Lugarno Amerigo Vespucci, was deserted, empty and surprisingly clean. The sun was streaming down on us like it was poured from a bucket, and sweat drenched our woolen uniforms.

The first part of the patrol had scurried down to the next building and had taken refuge in its large open door.

Our group ran across the street and took the places in the doorway that the others had vacated. It was in this manner that we hedge-hopped down the street. Shots were sounding above us and to the rear but nothing up ahead. There were so damn many balconies that it was hard to tell where the shots were coming from, so we would just duck and run.

We passed the Grand Hotel and then the Excelsior. After that I took a shot of a statue in a little square. The people in the United States liked to see their boys in action but they also wanted something in which they could relate. Something that would show them what middle town Italy looked like, too.

John yelled back to me, "What in hell are you taking a picture of that for? The only statue most know in the U.S. is that big one of Michelangelo's David up on the hill."

"John, that's Goldoni."

"Sounds like a magician to me," was his reply.

I tried to explain to John how Carlo Goldoni, a native of Venice, helped return the tradition of improvised comedy to the Italian stage in the late 18th century.

"He's the Italian Moliere or William Shakespeare or very near the equivalent."

Further down, the British lieutenant turned left and halted his patrol in the center of a large, broad, cool street. I shot a quick photo of the nameplate on the building, "Via Tournabuoni." Little did I know it was Florence's most famous metropolitan street.

We soon saw another prominent statue on top of a column, a blindfolded woman with the scales of justice in her hand. Slowly it seemed that the entire British patrol was beginning to take in the sights. Even the lieutenant in charge was interested more at looking at his Florence city guidebook, printed by the War Ministry, than he was at the map.

He looked around the open sector of the street. "I really believe that here was where Beatrice used to come to get water and Dante would meet her here."

From somewhere in the rear came a voice that said, "Is this a friggin' war or a bloody sightseeing tour?"

The lieutenant consulted his map, just like any other tourist, and motioned in the direction of a narrow, cool and shady street. As we walked

through the street, people came out of doorways and began to mingle with our patrol. It was getting ridiculous.

Here we were, in woolen battle clothes, sweaty and smelling like an Algerian Division, walking along with Florentines clothed in the lightweight materials that befitted the hot, sweltering August weather.

We did a considerable amount of sightseeing on foot in the area immediately surrounding the Pitti Palace and marveled at the splendor and greatness of the structure.

John and I could also see massive piles of rubble piled two floors high on both ends of the Ponte Vecchio from where we stood in the inclined courtyard in the front of the Pitti Palace. German engineers had systematically destroyed many of the medieval residential buildings nearby so as to block access across to the bridge in both directions.

Ponte Vecchio remains one of the most famous bridges in the city of Florence and is considered to be among the oldest in the city. The original structure consisted of three stone arches which replaced a wooden bridge that first crossed the Arno River at this spot in Roman times. The upper side of the bridge, known as the Vasariano corridor, was designed to link the Palazzo Vecchio and the Uffizi Gallery to the Pitti Palace.

We nervously walked down the narrow cobblestone city streets, looking in every direction for enemy activity, not knowing where we might end up. Armed partisans could still be seen ducking in and out of the old doorways looking for a still-hidden enemy.

Periodic bursts of machine gun fire crackled from the nearby rooftops and echoed through the empty streets. What people John and I could see moved quickly with each burst of gunfire, scared and looking for safety.

Not far from our location, where the sounds of active street fighting could still be heard, we walked up a different street to unexpectedly discover a cluster of Florentines happily dancing in the street in celebration, and taking sightseeing rides onboard the recently arrived South African Sherman tanks.

Enthusiastic Italian men, women and children eagerly climbed aboard many of the Allied tanks as they arrived and enthusiastically kissed their Allied liberators, making the entire occasion a mad, joyous, celebration. Local wine merchants soon came forth with their wares and even though some considered the occasion a little early in the day for such generous refreshments, nearly everyone joined us in downing several intoxicating glasses of Bacco's nectar.

The local partisans could still be seen bringing their dead and wounded into a small, nearby Catholic Church for medical treatment and administration of the last rites. We sadly looked on as the bodies of the dead were taken into a school building nearby.

As more and more Florentines joined our group, our patrol gradually got to be a city block long. Some of the people would walk along for a while, and then drop out, only to have their places taken by others.

Little by little our rag-tag caravan resembled a home front war bond parade. We still heard the frequent sounds of gunfire echoing down the neighboring streets.

The townspeople weren't afraid of what was happening around them, so why should we be. They knew the situation certainly better than we.

Italian children ran along beside us asking, in broken English, for anything we had. They recognized by our American uniforms that we were the only two U.S. soldiers in the group and paid us special attention.

I think I can say without contradiction that if Hershey and Wrigley ever made it big in Europe after the war, much of the credit is due the typical, American G.I. who did one hell of a great job advertising for them as they handed out free samples all over Europe.

I think the Germans also must have told the Italian children that all American soldiers were named Joe and that all had plenty of chewing gum and chocolate to give.

Young Italian children would hang onto our gun belts chanting, "Joe . . . hey Joe . . . you got shoeing gum . . . Hey Joe . . . chocolate."

Our mixed Allied infantry patrol moved across town without incident until we arrived in a large, open commercial plaza. We discovered many Florentines gathered in small groups going on about their day as though there was nothing at all extraordinary happening around them.

I guess they had become so accustomed to the war that nothing really meant too much to them.

I felt certain every one of them, in some form or another, had been touched by the war. You could see the sadness and weariness in their eyes. The only thing that could make a difference would be the end of the whole thing. They had watched the occupying Germans at close range and knew liberation would take some getting used to.

The British lieutenant held up the patrol while he checked in with his commander by radio to learn his group's next move.

Florentine civilians who were tagging along with us often stood there with their arms folded as though waiting for orders or direction themselves. No one spoke English or even tried.

We noticed how thin and tan they were and how shabbily they were dressed. They seemed shy and would just look at us and smile.

I later discovered that there was little or no work for anyone living in the city of Florence. Men, women and older children would leave their dwelling in the morning and roam the city, usually with a black briefcase or bag in

hand, trying to gather what little food they could find. Flour, potatoes or bread were scarce. Many generally ended up with eggplant which for some strange reason always seemed to be in ample supply. I suppose that accounts for their occasional disgust for the purple skinned vegetable as a food staple.

Our scouting patrol stopped not far from a small wine shop. The owner eagerly brought a full liter measuring flask of a dark red wine for all of us to share. While I considered it a little early in the morning to drink wine, I eagerly swallowed a very healthy swig out of proper respect for the owner's generosity, and then passed the flask around to the others.

The wine he offered us had a heavy, dry and acrid taste. The French might think to consider the taste of this potent beverage to be a "vin ordinaire," but its unusual pungent taste was one that would certainly have made ordinary people shudder.

I began the delicate process of loading film into my Speed Graphic still camera when an event happened which would have a tremendous bearing on the next year of my life.

I heard this soft and resonant gentleman's voice say, "You are both Americans, aren't you?"

His manner immediately caught my attention and I quickly looked up from my camera to face him. The sound of his precise, yet sophisticated civilian British accent, differed considerably from the decidedly crisp, efficient military manner of the other British and South African soldiers whom had gathered in the plaza near us.

The gentleman made one heck of an immediate and lasting first impression without ever revealing to us his first name. His immaculate grooming and polished manner contrasted sharply with the shabbily dressed Italians who stood nearby.

"Permit me. My name is Mr. Astor."

The gentleman who spoke was tall, very fit, tanned and very handsome. His thinning white hair was brushed and oiled back precisely from his forehead leaving a small tanned bald spot that became him. His bushy eyebrows matched the whiteness of his hair.

While I always wore both my Army dress and field uniforms with pride and tried to keep them clean, I'd have to admit that I was just a bit envious at that moment of the well-dressed gentleman then standing before me.

"I lived for many years in America—Hollywood, California to be precise."

Hollywood. It figured.

Mr. Astor didn't reveal his first name. It didn't matter.

Astor wore a pale beige silk shirt with an Edward VIII-style collar. Tucked inside was a brown patterned foulard. His crisp linen pants were a darker

brown in color. He stood in sharp contrast to my battered Army-issue combat boots and steel pot helmet. I looked down at his footwear which appeared to be luggage-quality, tan moccasins, undoubtedly pre-Gucci.

Lucky him, I thought.

Was this gentleman perhaps a second cousin of the well-traveled, affluent aristocrat John Jacob Astor, related to the hotel chain? I wondered.

John and I accepted the invitation of Astor's outstretched friendly hand and we each shook it vigorously.

"You see, at that time, I was married to silent screen actress Nita Naldi. Do you know of her?"

"Oh sure, I remember her. Quite a vamp," I said, offering Astor a cigarette while we introduced ourselves. The very lovely, dark-haired Miss Naldi achieved stardom on the silent screen as a co-star with Rudolph Valentino during the 1920s.

Appearances even during wartime are often deceiving. Astor looked like he stepped unexpectedly out of a Hollywood movie set. He looked and sounded impressive. After all, this was a social war and I felt I had met a celebrity.

I listened.

"After I left Hollywood, I was in Buenos Aires. I was president of the Jockey Club there. We had a fleet of large yachts. I love the sea. Do you like yachts, Mr. Mason?"

My partner, John Mason, looked at that moment rather unimpressed.

"Well now, Mr. Astor, I can take them or leave them."

I smiled back at John.

At that moment, I had no way of knowing what Mr. Astor had to say was true. I just accepted him at his word as a gentleman. I later found out that his story concerning his marriage to actress Nita Naldi didn't check out.

Throughout our combat travels and our adventures together, John always had a unique way of kidding on the square—or "squaring on the kid", as he said, whichever came first. I appreciated rather his wry sense of humor whenever we were together.

Mr. Astor told the two of us that he was living at that time in a friend's home on the opposite side of the piazza. He cordially invited each of us to be guests at his friend's home in the city for a cocktail later that afternoon, which we considered the best proposal we had been offered that entire day.

The war interrupted us once again and our military duties as Allied combat photographers soon called.

I drew a stubby yellow pencil from a pocket of my field jacket and asked Mr. Astor to write down his address on a piece of rather crisply-folded stationery he extended before me.

John and I said if our common German enemy cooperated, and ceased their shooting at us for the remaining part of the day, each of us would be delighted to see him later that same afternoon and meet his other English-speaking friends.

"Please, gentlemen," he said. "It would certainly be my pleasure."

Mr. Astor then turned and walked away. Our day had begun quite well and John and I each hoped it would end the same way.

Astor sounded like he genuinely wanted to see us again and introduce us to his friends.

We thought we would disappoint him if we couldn't take him up on his gracious and unexpected hospitality.

The British infantry lieutenant then leading the scouting patrol gathered his men and we soon headed north deeper into the city of Florence. Cameras in hand, John and I found ourselves zigzagged up narrow streets and past small piazzas until we came to a very pretty square with a tree-lined park in the center. The north side of the square was flanked by a Catholic church and the entrance to the University of Florence.

Our combat patrol then set up defensive positions in the center of Via Cavour, placing their heavy machine guns right in the middle of the street. The Italians gathered on both sides of the street to watch.

John and I found it rather odd to see the local citizens casually observing the unfolding situation from the nearby bars, sipping glasses of Bitter Campari as if the war was a secondary inconvenience.

In our humble opinion, the local Florentines took the occasion of their imminent liberation by British from years of fascist and German tyranny rather casually, and it showed.

We learned August 15, 1944, the actual day of our arrival with the British scouting patrol in Florence, marked a major national holiday in Italy. This specific day, coupled with a few days spread over the weekend, formed a four or five-day public holiday celebration where most local businesses, except for necessities like bars and restaurants were closed.

Whether or not the Germans intended to observe the holiday and leave town, we only guessed.

The two of us soon stood in a bar overlooking the Via Cavour swapping American cigarettes for generous refills of cognac when one member of the British patrol called us urgently back into the cobblestone street.

John and I left the bar and turned our attention towards the unmistakable clatter of steel tank treads against ancient cobblestones drawing steadily near.

I was certain it wasn't one of ours.

Not far down Via Cavour, steadily rumbling towards us as if he owned the street, came the menacing profile of a heavily-camouflaged German Panther tank.

The enemy tank stood about fifty yards away from us when it came into full view of the British patrol. The German tank commander sat upright in the open turret, scanning nearby rooftops and doorways with his field glasses. He certainly could not help but notice the British patrol stretched across the street in defensive positions but never the slightest sign of recognition.

All of us made such easy targets.

I wondered what the tank commander could possibly be thinking?

Our British officer in charge moved quietly about his men, urging them to remain very quiet, yet in a calming voice to keep their trigger fingers bent.

The British patrol had three heavy, and one light machine gun. Two bazookas, plus infantrymen in position with Sten guns evenly spread out defensively throughout the square.

The prominent long muzzle of the German tank soon was within range of all the firepower we could possibly aim at it. I glanced around me. I saw not a single Florentine in sight. They had cleared the streets for good reason.

I followed the motion of the German Panther tank through the viewfinder of my Speed Graphic still camera. The lumbering German tank slowly inched forward, narrowing the distance of imminent death between us narrowing in every moment. Without warning, this Frankenstein's monster paused, locked its right track and abruptly twisted to the left.

The British soldiers held our fire.

I could see the German tank commander issue an order to the driver below him to change the tank's direction. The Panther made a series of urgent, sharp, pivoting movements to the left and moved diagonally away from our position toward the tree-lined perimeter of the piazza square.

John and I watched as the German tank corrected its direction once more, now moving parallel to the facing buildings, casually snapping the thick, overhanging branches of the surrounding trees that lined the piazza square, one by one.

Moments later, the Panther reached the far end of the piazza, made an abrupt swing up a narrow diagonal side street that was flanked by the University of Florence and disappeared through a cloud of diesel smoke out of sight.

John and I were utterly surprised that not a single shot by either side had been fired and everyone walked away unhurt.

My hands were still dripping wet with sweat and I later discovered that in the intensity of the moment, I never once squeezed the shutter of the camera to take a picture of the German Panther only yards before me.

Our patrol received orders to hold its position where it was and to move up to another point covered by darkness later that same evening. With the failing light of the end of day, huge shadows stretched out on the stone floor of the square like huge giants lying down for the night.

Our photographic mission for the day had ended, and John and I gathered our cameras and backtracked towards the Arno River and the large piazza where we had our first encounter the memorable Mr. Astor. We decided we had sufficient time to pay him a return visit and found the address he gave us.

John knocked on a thick, weathered oak front door.

Astor greeted us like we were friends of long standing.

"Mr. Mason, come in. Mr. O'Connell, I am happy the two of you could return."

We were ushered into an attractive, opulently furnished apartment, in the modern style of the 1930s. Its current owner, Signor Paoli, was a well-known merchant in the wholesale fruit and vegetable field in Florence. Paoli appeared to be in his mid-30s, a handsome well-nourished man who did not reflect the haggard look of so many Florentines we encountered earlier in the day.

Signor Paoli introduced us to his wife, a very attractive, dark haired woman close to his own age, who bore a striking resemblance to actress Elizabeth Taylor.

John and I were surprised to find that our generous hosts had such an ample supply of liquors on hand.

Mr. Astor kept the flow of our ongoing conversation going in both English and Italian translating for the Paoli's who spoke little English.

Signora Paoli was quite a flirt, moving her lithe body suggestively when she moved throughout the room.

I offered to help her fill some empty ice trays with water which she modestly appreciated, but my actions were always under the watchful eye of her husband, Signor Paoli, who was built like a wrestler and had hands the size of hams.

All of us were having a terrific time, and as it so often happens when everyone involved has had more than a few drinks, all sorts of plans to meet again the following day begin to formulate.

John and I confessed to a certain amount of flexibility as far as our time away from our military duties in the city of Florence was concerned. We each welcomed Mr. Astor and Signor Paoli's plans for a big luncheon at the home the next day and we accepted their invitation with little hesitation.

Paoli then described a female friend our age who spoke English quite fluently and said he would invite her and several other of his friends to join us.

We were delighted that our new friends had arranged an exciting afternoon luncheon for us to enjoy tomorrow. John and I excitedly shook hands with everyone at least two or three times and excused ourselves.

While the two of us walked back towards the Arno riverbed towards where we had left our jeep and equipment, we each said to one another our first day in the city of Florence had been a successful one.

Some trigger-happy Italian fascist black shirt had not taken a shot at us, or if he had, didn't hit us. We had also met some very friendly Florentines, and from all indications we had quite a promising social life cut out for us.

John and I each offered our special thanks to whoever in the heavens creates such wonderfully unexpected moments in our lives and especially arranges to have them take place in such a beautiful city like historic Florence to experience them in.

Chapter 2

A beautiful stranger

Florence, Italy

John and I rolled out our sleeping bags and slept under the stars in a city park near the Porto Romano. We decided the next morning it was absolutely essential to find a way to drive our assigned Army jeep safely across the Arno River to the other side.

All of our film supplies and bulky camera equipment were much too heavy for us to carry across on foot given the distance to the other side of the river.

We also could not gauge for ourselves given what few maps we had how large the city actually was. Our Army jeep and trailer would make us mobile and then, too, since the Florentine people on the other side had before never seen one, we decided, why not give them a special treat also and drive one of the first Allied jeeps across the Arno.

The Arno River, during the summer, contains very little water and consequently the shoulder embankments are mostly bare, dry earth. Many Florentines had cultivated small victory-type gardens along the sides when the war began.

Our immediate challenge was to find a modest clearing somewhere along the Arno where the stone walls that generally lined the river bank on both sides did not exist or could be driven over.

I took my turn behind the wheel of the jeep the August 1944 morning John and I decided to cross the Arno and found it necessary to drive a considerable distance upstream before we found a small path that led down from the street to the river bed below.

Once in the river bed, we followed the contours of the dry bottom a little further until we hit a weir, much like the one we crossed on foot the day before into the city. We crossed this weir, but once on the other side, discovered we had to travel upstream by jeep to find an opening through the retaining wall, which we eventually did find with a little effort.

John and I drove the jeep up the length of a small trail and then burst out from an opening in dense brush into a main street running parallel on the opposite side of the river.

John and I proudly claimed our jeep was the first American jeep to cross into downtown Florence.

Had John and I brought a circus truck full of colorful clowns and squawking monkeys we could not have attracted the crowd we did that morning with the presence of our little jeep.

Our first stop was in Piazza Vittorio Emmanuel. People quickly crowded around us and spoke Italian mixed with English.

I think most were attracted by the unfamiliar sight of our jeep than by the two of us, two American photographers who happened to be there.

John and I were eager to take the photo of nearly anyone who asked. Waiters from the nearby Guibbo Russo bar where we had parked our jeep walked out from inside their restaurant to generously offer us cognac by the glassful. An ebullient street entertainer also came over and began a juggling act aided by a trained chimpanzee.

You could sense the immediate wave of joyous euphoria that swiftly descended over the piazza before us. These Florentines, certainly for the very first time, sincerely felt that there really was an end to the war in sight, and the presence of this one lone Allied military vehicle represented the whole mechanized force of liberation which was destined to come.

John and I drove the jeep throughout the city streets of Florence, spotting not a German in sight. We drove up and down crooked cobblestone streets, often repeating ourselves to the point of getting lost.

When we least expected it, zing—our Army jeep would shoot out into a large, familiar piazza where we would start our exploration from comfortable, known surroundings once again.

We found our way up the Via Cavour towards a large traffic circle at its end. On the other side of the circle we encountered a British infantry lieutenant and a cluster of troops then on patrol. The battle for Florence had by then quickly moved forward and these British infantry soldiers who were a different group than those we had followed the day before now had received their orders to join up with the rest of their division which were now crossing the Arno River further to the east.

John and I learned from our British commanders that the operations sector north of the city of Florence soon would be taken over by forces of the then advancing U.S. Fifth Army.

We each exchanged goodbyes with our new friend, and ended our connection with the British 8th Army. We were never to work with our British allies on a photographic assignment of this type again for the rest of the war. Between August 9 and August 24, 1944, the bulk of the British Eighth Army was secretly switched to the Adriatic sector from Florence where it would begin its own spring offensive north.

John and I watched these proud Tommies march out of site up the Via Bolognese and continued on our morning journey.

We were eager to keep our luncheon engagement with our new friend, Mr. Astor and the Paoli's.

Our luncheon turned out to be quite elaborate and handsome for a hastily put together affair on short notice in wartime. Along with the Paoli's and Mr. Astor, we were also joined by a baroness of German origin, who was described to us as a close friend of Mr. Astor's.

We also met a Mr. Vivarelli, who said he once owned a family jewelry store on the now-ravaged Ponte Vecchio, and had no place to work. He shared his hopes that the rapid reconstruction of the Ponte Vecchio by both the Allies and the people of Florence wouldn't take that long.

John and I politely asked Mr. Astor about the arrival of the additional English-speaking female guest he described to us the day before who was yet to join us. We were told that she would soon join us, but was delayed by a previous engagement.

Our lunch was a welcome full feast, the likes of which John and I had not seen for too long to remember. We had brought along some Army food staples to contribute to the affair, including portions of sugar, salt, coffee, and a can of slab bacon.

Surprisingly enough, it was a single dented can of GI slab bacon which turned out to be for its inclusion in the main antipasto dish, the very real treat of the entire meal. Our GI raw bacon, sliced very thin, resembled in look and taste, cured Italian prosciutto.

John and I provided an unexpected, welcome treat for our Italian hosts which neither of us could believe. I could read Mason's thoughts across the table as he noticeably grimaced back at me.

"Christ, Burke, how can they eat raw bacon? Oh, boy!"

I wondered to myself the very same thing.

I wasn't surprised that John and I abstained on that occasion from eating the familiar GI delicacy, preferring ours cooked as only Army mess sergeants can honestly abuse it.

Our luncheon meal consisted of freshly made egg noodles with butter, cheese and small peas, and a molded soufflé type dish made from the similar shells of the same small, fresh peas.

The main dish was a wonderful, piping-hot, flavorful, lasagna-type eggplant dish fresh from the oven. The dish bubbled over with fresh tomatoes, cream sauce and melted mozzarella cheese.

For dessert, John and I enjoyed thick slices of a large, flavorful fluffy cake made from potato flour topped with fresh wild strawberries and chilled whipped cream. Fresh fruit and several types of table and dessert wines were offered to us as well.

It became obvious to John and I that the Paoli's by virtue of their status suffered little as the war surrounded their public lives. No surprisingly, people in higher positions always seem to be in the driver's seat when it comes to obtaining food and other precious commodities in exchange for something equally valuable.

After lunch, John and I sat drinking cognac and exchanged small talk with our Italian guests. Signor Paoli soon heard a knock at the front door and returned to introduce our additional female guest—the one he said who spoke fluent English.

Mr. Paoli introduced us to Tina Calamai, and John and I were quick to put on display for her our best and most humorous American charm.

I don't know what I expected, but I know I wasn't prepared for the woman I saw. She introduced herself to me, and her immediate first physical impression seemed more English than Italian in appearance. Tina wasn't especially beautiful, but to me, she was sweet and charming, and looked to be in her early thirties. She had light, chestnut hair which fell in soft curls across her forehead.

She smiled embarrassedly and spoke haltingly, perhaps afraid that her British Institute English might not be so easily understood by us two Yanks sitting across from her.

"You are, Americans?"

I guess that phrase was the universal ice breaker in most all languages. We both agreed that we certainly were. John told her he was born in the city of Detroit and I told her I had made New York City my pre-war home.

Tina described her love for the United States and all the popular American films, music and clothes she thoroughly enjoyed before the war. She apologized to each of us, saying that her current knowledge of more recent American films and music was considerably limited, due to the decision by then Italian Dictator Benito Mussolini to embargo American products at the start of the war because of our criticism of his nation's decision to invade Ethiopia.

Sadly, Tina said, there wasn't too much of Hollywood or Tin Pan Alley to be had in Florence since the war began.

When Tina told me that I resembled one of her favorite handsome, dark-haired Hollywood actors, Nils Asther, I realized how very long the embargo had been and how effective it was in shutting Italy off from the outside world.

Asther, who did resemble me in a modest way, was born in Sweden and invited to Hollywood in 1926. He was a successful actor in Hollywood through the early 1930s. He had co-starred opposite legendary actress Greta Garbo, but his strong Swedish accent didn't help his overall popularity in sound films.

I had an immediate sense, considering the warmth of our dinner conversation that all of us, including Tina and I, were getting along rather well.

Signora Paoli soon discovered that since my interest in her had faded, she would have to get her ice trays now all by herself.

The Paoli's had a crank-up manual phonograph player and we all tried to dance along to Marlene Dietrich as she sang her popular recording of "Jonny" in German and to a song well known to most American soldiers of that era, "Lili Marlene."

I beat out a conga rhythm and taught all of our guests the conga—one-two-three-BUMP.

All of us soon formed a joyful, weaving conga line and we danced all over the whole apartment just as I had seen in the great pre-war American film, "My Sister Eileen."

Our awkward steps certainly weren't actual dance steps, but John and I were clearly having so much fun with our new friends that it didn't seem to matter very much to us. I felt just as joyous as I had in the Florence city square by our jeep earlier in the morning.

Each of our Florentine friends shared a true sense of hope that the liberation of Florence had finally come at long last, and the end of German occupation throughout Italy would soon end. Sadly, the liberation of Italy from the grip of the German control would take nine more bloody months to accomplish.

Tina and her friends each described to us their own thoughts about daily life in the United States from the perspective and recollections of their fellow Italians who left Italy before the war began to start new lives.

In between dances, I found time to talk to Tina privately. I had subtly noticed that she wore what appeared to be a silver wedding band.

I asked her, "Are you married?"

Tina looked demurely down at the modest silver band on her forefinger and sadly replied.

"Yes, I am."

"Why are you so sad?"

"I don't know," she replied.

"Where is your husband now?"

I suspected perhaps Tina's husband had been killed or taken prisoner earlier in the war.

Her swift answer caught me by complete surprise.

"He's playing bridge. That's his greatest hobby. He's actually quite good."

I was shocked, to say the least. "Here there is a war surrounding this city, the people are feeling liberated for the first time in many years, and he is busy playing bridge." I was dumbfounded and speechless.

She smiled modestly and said somewhat convincingly, "It's better that he is. Otherwise I could not be here."

I kidded her.

"So your husband's the jealous type, huh?"

"No, he's just possessive." She continued, "If I see you again, Sergeant, I will tell you about him. But for now it is just a waste of time."

Tina's look towards me told me more than she then chose to let on.

I coyly challenged her reply.

"Is that an open invitation to see you again?"

"If you are here, and you like. We can meet here. I have another female friend named Rina. She is from Milan. I think your friend John might like to meet her."

Tina sighed with resignation. "No one works anymore now, so we always meet here at this home and talk in the afternoon. We have some tea and cognac. It's our only amusement. Paolo and Eugenio are old friends from when we were each in school. At night, there is a city curfew, so we must stay at home indoors."

I told Tina how John and I had hopes of staying in the city at least for as long as we could. Fifth Army engineers would eventually construct some Bailey Bridges across the Arno River allowing troops, tanks and artillery to cross, but the city of Florence itself would not become rear operations area.

John and I extended an invitation to Tina and Rina to meet us the following afternoon after four p.m. at Mr. Paoli's home and we would try to set aside some time to sightsee in Florence.

I again became curious to learn the story behind the silver wedding ring Tina wore discretely and pressed her to tell me more details.

"It's not silver, but platinum."

Tina explained in more detail. "You see, when Mussolini needed money to pay for the war, he made all Italians donate their wedding rings for the good of the country. The government gave you a ring in return made of steel."

"My husband, Giuglio, in a moment of tenderness, bought me one made in platinum. At the same time my ring resembled all the others. But had they known it was made of platinum, Mussolini's fascists would have taken my ring from me."

"So, all the Italian people's wedding rings were melted down to finance a war in the African desert?" I asked.

"Don't you worry.

The precious metals never made it any further than Rome, like everything else Mussolini took from the people."

I gently took Tina's hand in mine as I bid her farewell.

I told her I looked forward to seeing her again, and I sensed in her eyes the feeling was mutual.

I did not know where Tina lived and it was probably just as well. I said to her I would come to the Paoli's whenever I could.

I knew my return to Tina's side was at best indefinite, but then, that's the way wars often are.

Our first meeting marked the mere beginning of what would become a long series of missed appointments, anxious periods of waiting for me to return, but very affectionate reunions.

John and I met Tina and Rina the following day at the Paoli's home and then later on, the four of us took a drive through the city of Florence in our Army jeep.

Tina introduced John to her good friend Rina, a very cute, vivacious, round-faced girl also in her mid-thirties. Rina's immediate grasp of English was somewhat limited, but she always managed to connect her words and thoughts together, but not always in the right sequence. I think that's part of the challenge and the fun of learning any new language for the first time.

Rina tried very hard to share with John and I her knowledge and appreciation for Renaissance art with only limited success. She would often use the most complicated method to arrive at a simple point that, when she did, the whole thing was so removed that it didn't make sense.

Once, Rina wanted to say that prudish American tourists were often offended by the large naked statue of Michelangelo's David that stood in front of the Palazzo Vecchio with all his manliness hanging out.

To make her point, Rina started out by talking about people with their clothes on, and then she would explain that they would be removed to look like David. Of course, however, they would all have to be male people.

Then John would argue, and he wasn't of much help, that most Americans usually wore clothes, maybe not all the statues, but the people did.

Poor Rina would get on the tack that the Florentines did not wear clothes and the statues were naked.

Finally, with all trying their best to get at Rina's original statement, John came out with, "Hell, I don't care if David wore clothes or not. But I think he could use a jock strap."

Rina would turn to Tina and ask inquisitively, "Jock strap, what is?"

John and I drove our female companions up to the Piazza Michelangelo to look out over the city, a view difficult to equal anywhere.

We teasingly amused the girls by our pronunciation of the famous artist's name, pronouncing it with a "Mike" instead of a "Mick."

Near the Piazza Michelangelo, we stopped for a late afternoon meal. The owners offered us chilled wine, beignets filled with cream and some wild strawberries with whipped cream.

Gradually, John and I began to delicately unravel the life stories of our two very attractive and often coy Florentine signoras who began to tell us about their personal lives.

Rina said she was originally from Florence and was a school chum of Tina's from their early years. Her family had once owned a very fine restaurant in Piazza Strozzi.

Her older brother, Aldo, had studied art at the best schools and was on his way to becoming one of Italy's leading painters.

Her family was struck by unexpected tragedy when a colorful parrot that adorned the entrance to the restaurant contracted a fever-borne illness and quickly spread a near deadly infection to her family.

The bird passed the infection first to Rina's father and then others working in their restaurant. Rina's father died from the infection, as did one of the waiters. Her mother also became violently ill from the same infection and both of her parents remained near death for some time.

Rina and Aldo were away from the family restaurant at the time and consequently, were initially spared from what might have been a complete family disaster.

Since Aldo was in Milan, Rina went there and studied artistic weaving and later became quite well known as a designer of textile fabrics. She described how she was visiting Tina at her family villa earlier in 1944 when Mussolini's Italian Army surrendered and the Germans took over. From then on, both Tina and Rina found it was virtually impossible to travel to the northern Florentine countryside.

I wasn't prepared for the story Tina then told me. How many young Florentine women had the privileged opportunity to spend their childhood growing up in a 15th century Medici villa that had been owned by her family for successive generations?

Her family home that I came to know as the Villa Calamai, was her home before Tina was married and where her father still lived. It was an odd thing

how the people got by with the war conditions yet still managed to provide themselves with the maximum safety and also the best possible livelihood during the chaos around them.

While the front lines of the Italian campaign were for us, John and I, a long distance away, the safest place for many Florentines and Italians alike during the conflict was further out in the country, not within or near city limits.

The frequent Allied and German aerial bombings still took place mostly in the cities, large and small. The immediate need for survival demanded many families, especially those with young children or older, more vulnerable family members to refuge with local farmers in the countryside sharing food, shelter and dividing what few meager possessions that remained. Scarred by war, the rich Italian soil could still yield some form of subsistence to its citizens.

When the front came closer, even the countryside was no longer a safe place. Retreating Italian soldiers needed all they could get. They took whatever food they could find, killed what animals weren't hidden away, and took over homes, vehicles and everything that might make their route to safety, a better one or an easier one.

Tina, her husband, father, Rina and some friends had been staying in the villa during all the period since the surrender of Italy. They had moved into the safety of the city of Florence only a few months before Allied troops liberated the city.

All of us knew that the liberation of Florence was far from complete. Signs of an unfinished civil war remained.

Even now, Tina said there were people still living in the Villa Calamai who worked for them. She asked if John and I would have any chance to travel to the villa by jeep, as she was anxious to know of their fate.

Tina gave me a note to give to Beppa, whom she described as the cook and a faithful person who had grown up in the household. She also told us to find a woman named Maria who did laundry and housecleaning at the villa. We might also find Lucia, a young maid, and Ernesto, a chauffeur for Tina's father and general handyman, who had traveled with Tina and her father to Florence.

Tina then sketched me a map with the general directions to the villa. I reluctantly told her many roads in the immediate area near the villa were still blocked due to recent combat activity, and most of the smaller bridges leading there were now destroyed.

I had to tell Tina that if such a visit to the villa did become possible, John and I would make a substantial effort to try, but we honestly couldn't promise when.

We also weighed the dangers of traveling to the villa against what each of us knew the trip meant personally to Tina. I liked the idea of being able

to help her, and I didn't want to say no. I was also attracted by her curiosity about the current condition of the villa and its inhabitants, and fancied the possibility of returning there with me.

Reality demanded a different outcome.

Tina was sharing an apartment with four other families and the thought of her getting out of Florence as soon as possible and back to the villa must have been constantly on all of their minds once the Allies forced the Germans out.

I enjoyed meeting Tina for the first time and was delighted to have been able to spend some time with her, however brief it might have been.

I was especially eager for any chance that fate might offer to let me see Tina once again. I felt genuinely touched by the warmth of our first meeting and I felt clearly that Tina was someone I found very easy to like and wanted further to get to know.

How and when we would meet again were burning questions for which I had no immediate answers.

Chapter 3

Lights, camera, action!

Not much is known what motivated my late stepfather, Burke O'Connell to leave his birthplace of Nashville, Tennessee to pursue his personal dream of a theatrical career in New York City. Burke described himself to others as a self-made man and one who matured quite young. He may have been the oldest of three children. His personal Army pay records lists next of kin as a sister Ann also of Nashville, and a brother, James of Buffalo, New York.

His mother, Katie E. Sheas, born in 1800, was 34 at the time of his birth and 61 years of age when he went into the Army. His father, James O'Connell, born in 1871, was 43 at the time of his birth in Nashville, Tennessee but he passed away before the start of the Second World War.

When World War II did eventually break out, I could not have landed a better wartime job as a soldier, even if I had used friends or outside influence than that as an Army combat photographer. I recall I really didn't land the job, I fell into it.

In 1939, at age 25, I moved from my former hometown of Nashville, Tennessee to the bright lights of Broadway to pursue my dream of a theatrical career. I had been around the New York theater scene finding work as actor, extra, stage manager, and assistant director, accepting whatever other part-time work which came along.

I was also fortunate before the war to land supporting roles as an actor in the regional touring theatrical companies of two successful Broadway plays which played the New England theater circuit.

The plot of *Brother Rat* revolves around the antics of Virginia Military Institute (VMI) cadets in their final months before graduation and holds

a special place in the lore of the Institute as it starred actor-turned-future president Ronald Reagan. I also joined actor Gary Merrill, who later went on to marry actress Bette Davis and who starred in more than 50 feature films during his own career, in the New England touring company of Kurt Weill's ambitious epic Broadway musical, *The Eternal Road*.

The play caused an immediate sensation of the 1937 New York season. Originally conceived as a biblical pageant, a profound music-drama, and a theatrical extravaganza, *The Eternal Road* combined the legends of timeless Jewish heroes and heroines with the all-too-familiar story of persecution in Europe.

I shared what one would describe as a typical, sparse, mid-town Manhattan bachelor apartment with three equally struggling actors my age. My roommates included my good friend, Garnay Wilson, from Denver, Colorado; actor Tom Tully, who found success after the war in film and television in Hollywood, California, and Richard Wilson, who then was an eager disciple of popular director Orson Welles and anxious to find fame in a similar satisfying film career.

All of us took jobs in radio, then the most popular form of public entertainment in the day, either as actors or script writers, and earnestly jumped at any paying job which would help contribute to our modest rent.

I thought I would find success as a radio script writer and tried my hand writing for one of the most popular radio soap melodramas of the day, *Stella Dallas*. Film director Samuel Goldwyn scored a box office bonanza in 1937 with actress Barbara Stanwyck delivering a powerhouse performance as a single mother who drives her daughter away so the girl can find a better life. The success of the movie of the same name inspired a long-running radio serial about the further adventures of Stella as she continued to fight for her daughter's happiness.

I soon discovered I wasn't cut out for the demands and pressures of that kind of ongoing scriptwriting grind.

My professional acting career also had a "chilly" phase when I accepted a memorable acting role of an entirely different kind. I began a four-month character role on a popular American children's radio serial, *Renfrew of the Mounted Police*, by playing an Eskimo!

The half-hour children's radio program sponsored by Wonder Bread, which aired between the years 1938 and 1940, had a very memorable opening sequence.

Audiences would hear the urgent cry, "Rennnnnnnfrewwwwww! Renfrew of the Mounted!" and the haunting sound of a baying wolf call which opened the further adventures of Inspector Douglas Renfrew as he battled deadly criminals at large and defenseless children lost in the forests and mountainous regions in the northern provinces of Canada.

I faked an acceptable Eskimo accent and mumbled the Lord's Prayer as needed in Latin when I had to improvise.

I developed a measure of acceptable fluency in Latin, thanks to a helpful Catholic priest, Father Morgan, who offered me regular paid work as his touring altar boy, assisting him as needed during Masses for outlying convents or churches in the metropolitan New York area whom did not have a full-time parish priest assigned as their own.

My pre-war professional career was on an upswing and I caught a welcome break in early 1940 when I found clerical employment in the Columbia Broadcasting System (CBS) Music Department. My initial tour of duty with CBS radio coincided with the American Society of Composers, Authors and Publishers (ASCAP) strike that year.

ASCAP was the first, and is still the largest of the American performing rights societies, which collect and distribute royalties to members from the use of their music.

ASCAP members began a 10-month contract dispute with the nation's radio networks in December 1940. Their issues weren't resolved until just after the United States entered the war in 1941. The labor strike against radio broadcasters led to an unusual period in which only public-domain music was broadcast on the nation's radio airwaves.

After a tour of duty with the CBS Music Department during the ASCAP strike, I was promoted and offered a new job during the summer of 1941 by Roy Langham, then head of its production department.

My new boss at CBS was young like I was, at 27, but an experienced broadcast professional who knew his stuff. Roy had started out in his professional life as a musician and was one of the nicest persons I ever met while living in the city of New York.

I suppose if I had thoughtfully listened to Roy's helpful advice and honestly considered the career path he outlined before for me, I might have been promoted to vice president of CBS one day.

Radio was certainly among the best possible places to be employed during the pre-war era. The medium was at its height of popularity for entertainment, news and information in its time.

I felt much of my hard work and effort had finally begun to pay off as I worked towards fulfilling my dream of becoming a successful actor.

The city of New York was brimming with bright, young, talent in those wonderful days, and I'm still amazed to recall just how many who went on to discover satisfying careers in motion pictures, Broadway and on television when their military service during the Second World War had ended.

I felt the urgency to serve my country as other young draft-eligible men then my age, and I knew very little would keep me out of the service when

the United States did declare war. I reported to my local draft board to register for the 1940 draft and then patiently waited my turn to be called up.

Broadcast engineers assigned to CBS's Manhattan headquarters control the radio network's daily operations and all the essential technical equipment necessary to keep the network's broadcast signal on the air.

I happened to be attending to my regular duties at CBS during the weekend of December 7, 1941 when most of its daily employees were happily at home actively enjoying what would turn out to be their last peacetime weekend we would ever enjoy for a very long time.

I was minding the store at CBS and thoughtfully listening to efforts of the talented maestro Arturo Toscanini to mold the New York Philharmonic Orchestra into the robust, dynamic symphonic voice he led so well.

The tranquility of that pleasurable moment was abruptly shattered by the shrill, metallic, ringing of my desk telephone, and the nearly simultaneous startling, sudden thump in front of me of an air tube canister landing in front of my desk which carried an urgent teletype message.

I quickly opened the cartridge and took out the curled, paper document. The first visible line of the message, typed in all underlined capital letters, which read "Full Network—Immediately" meant very little to me at first. It wasn't until I took a much closer look that the profound shock of its message fully hit me.

I immediately sought one CBS News announcer I knew then on duty whom I could find, Ted Reams, who by circumstance just had happened to be in the men's room.

Ted grabbed hold of his pants and the bulletin I urgently handed him and we both quickly raced from the men's room into Studio Y, a small telephone booth of a studio used to broadcast immediate radio news flashes.

Within moments, Americans from coast-to-coast heard for the very first time over the airwaves, that our naval base at Pearl Harbor, Hawaii, had been viciously attacked by the Japanese.

I also remember John Daly of CBS News interrupted our network programming to announce that the Japanese had attacked Pearl Harbor, Hawaii.

When the words, "Pearl Harbor" burst out, I asked as did many Americans, "Where in the hell is that?"

Chapter 4

You're in the Army Now!

Burke's initial Army service at the Signal Corps Photographic Center (SCPC) during early 1942 assigns him to enlisted duties as a military newsreel scriptwriter. By fall 1942, he had been abruptly reassigned from SCPC for reasons unknown to him, given orders overseas, and upon reporting for duty, received a motion picture camera from Hollywood producer-director Darryl F. Zanuck, to film Operation Torch, the combined British-American invasion of French North Africa which started on November 8, 1942.

Within this time period O'Connell receives his official military press credentials from Armed Forces Headquarters (AFHQ) to provide official still and motion picture photo coverage of Commanding General, Dwight D. Eisenhower, Supreme Commander Allied Expeditionary Force, North Africa.

It didn't take long in early 1942 before officials at my assigned downtown New York draft board found me sufficiently qualified for military service, and I stood naked as a jaybird, freezing my balls off waiting in line for my required Army physical.

I listened to an Army shrink ask me if I liked girls, and once I gave him the correct answer he was looking for, he soon sent me on my way. Uncle Sam welcomed me to Army basic training at Fort Dix, New Jersey, and military life as a raw recruit.

Fort Dix had served as the Army's reception and training center for men inducted under the 1940 military draft before it got a hold of me.

I slept in a tent, often froze my ass off, and rose every morning at 4:30 a.m. to stand in formation for routine roll call.

It didn't take very long to figure out that since our platoon sergeants couldn't read our last names very clearly in the dark to begin with, they sure

as hell couldn't see much of our individual faces. Our platoon leaders, regular Army soldiers from Hawaii's Schofield Barracks, found they had to use the limited available light of an Army flashlight to read our last names on their personnel rosters.

We quickly devised a clever solution to the Army's daily requirement to stand out in formation in the freezing cold waiting outside our tents for our names to be called at muster.

Each one of us simply took turns standing in formation in the morning and answered when called to each and every one of our last names on the morning muster list. Our platoon sergeants had too many new recruits to count they didn't catch on.

I realized from that point on that anyone with a modest amount of cleverness could beat the Army system. Military service in any branch remains a playful game of personal survival, and you had to stay even with the guys running the system or, if you could swing it, manage to be one modest step ahead of those in charge.

After basic training, I reported to the Army training center at Fort Monmouth, New Jersey, where I polished my administrative skills as a company clerk. The Army decided it might be more useful to put a typewriter at my fingertips than an M-1 rifle immediately in my hands.

My two new service buddies then included a writer named Phil Freund, a small, rather sweet guy, who I recognized had no place in the Army; but got caught anyway, and Jimmy DeGaw, whose generous rear-end made him overflow the Army's smallest schoolroom chairs.

Jimmy had become known to us as the poor man's Wallace Beery because of his general resemblance to the character film actor. He also worked in Hollywood, California before enlisting in the Army as a script writer and actor through the early 1930s and into the 1940s, writing under the professional name of Boyce DeGaw. Jimmy wrote screenplays for some of the earliest movies starring actors Henry Fonda and Margaret Sullavan. His last professional writing credit before joining the Army in 1942 was for *Lady for a Night*, starring John Wayne and actress Joan Blondell.

Phil Freund, Jimmy DeGaw and I were soon joined by Eric Eisener, a recent refugee from Czechoslovakia whom Uncle Sam also summoned into military service. During the early 1930s, Eisener had worked in the European film industry and received production credits for a series of German commercial film projects for Bata Shoes, a prominent Czech shoe company, which starred an exceptionally beautiful, but yet unknown Austrian actress named Hedwig Eva Maria Kiesle.

Kiesle's memorable role in the 1932 German film, *Ecstasy*, brought her to the immediate attention of Hollywood producers. She soon signed a contract

with MGM and officially changed her name to Hedy Lamarr. She is best known today for her patent of an idea that became the basis of both secure military communications and mobile phone technology.

I thought the Army was sincerely trying to be sure I'd never be destined to see any sort of combat during the war and leave me forever in a stateside administrative typing pool.

Our fortunes changed when the four of us read a feature news story in our weekly Fort Monmouth, New Jersey base newspaper that the Army's modest pre-war photographic section was being aggressively expanded to form the Signal Corps Photographic Center (SCPC), and had now taken over the site of the former Paramount Studios in nearby Astoria, Long Island, New York. We decided we would take leave of our dull administrative duties and request immediate individual transfer orders to the exciting world of SCPC.

The non-commissioned officer in charge of our administrative section at Ft. Monmouth vehemently denied our transfer request, on the sole basis that writers like each of us who knew how to type, should be assigned to the Signal Corps's teletype sections where they were more urgently needed. Our enlisted superiors didn't see our cause quite that way, and seemed delighted to leave us in the typing pool where they felt each of the four of us best belonged.

We didn't give up our desire for a transfer to the Signal Corps Photographic Center in Long Island City, New York, and our fortunes swiftly changed when we received some welcome news.

The Signal Corps Photographic Center (SCPC) had received a new priority manning order from the War Department later in the summer of 1942 which meant it would accept the automatic transfer of anyone who applied. All four of us couldn't be held back, and we were soon on our way to the start of a much more interesting and rewarding career opportunity.

Col. Melvin E. Gillette, SCPC's first commanding officer, had organized and directed Fort Monmouth's first training Film Field Unit in 1937 and the first Training Film Production Laboratory in 1940. The lab had moved to Long Island City from Fort Monmouth in 1942 and was incorporated into the new center.

By late summer 1942, the studios at the Signal Corps Photographic Center were a bustling place; full of impressive looking production sets straight out of Hollywood, with three or four theatrical length films each shooting simultaneously on site. Busy teams of film cutters and production editors hustled between each of the productions and their own comfortable air-conditioned offices. SCPC was also close to numerous commercial film labs in New York City and its ranks steadily grew to 445 officers, enlisted men and civilians.

The writers' section at SCPC was cramped into a sparsely furnished cluster of offices with few barely discernable outside windows. I was fortunate to have then been promoted to tech sergeant and welcomed the added enlisted stripes and additional modest pay that came with more supervisory responsibility.

The Hollywood film industry had mobilized fully in support of the overall war effort, and the ranks of our immediate superiors at SCPC reflected its leading executives who entered Army service as commissioned officers for the duration of the war.

The War Department made certain that each new commissioned officer from the nation's film industry received the same level of prestige and status in their executive studio offices as they voluntarily left behind in Hollywood. You couldn't help but rub elbows with notable Hollywood who's who of prominent film actors who had joined the enlisted ranks to serve their country. Actor William Holden worked in the Astoria studio during the same period of my service at SCPC and lent his voice-over to many of the finished films I worked on.

The Army's Signal Corps Photographic Center also had its own everything; its own pettiness, its own intrigue and its own inscrutable internal "back room" political power structure. It was within this intricate social web that I was propelled on the road towards the greatest adventure of my life and eventually into the arms of an attractive Florentine, Tina Calamai.

Without some modest measure of my immediate involvement with that petty intrigue, I might have lived out the entire war years fighting what was laughingly called home front's "subway war" in New York City.

I was assigned to a section called Film Bulletins which produced a general home front newsreel that informed the public about typical Army life. I helped produce a narrative script for the various subject topics that formed each specific newsreel. My immediate section chief, Sergeant Mills, generally drew the cream of the writing assignments in our section and I was stuck with whatever lesser assignments were left. My initial script writing efforts for the Army described the important and crucial wartime role of mobile bakeries, shoe repair units and laundries towards the general war effort.

I moved up to more interesting subject matter when our entire scriptwriting section was put to work to help produce a feature film in support of the nation's first major war bond drive which began on November 30, 1942, and continued until December 23, 1942. The film included a wide range of stock film footage of Army training exercises, parades, field maneuvers, and an impressive list of popular Hollywood film stars in a razzle-dazzle, real flag-waving production.

Our entire enlisted script writing section watched anxiously from the rear of the screening room as a number of high-ranking Army brass prepared to

preview the completed film kicking of the nation's first war bond campaign drive.

The visiting generals, led by our studio's chief, Colonel Melvin E. Gillette, sat in the front row. The rest of the seats were filled by lesser ranking officers, and our immediate officer in charge. I stood in the back of the screening room beside the film's chief enlisted editor, Mickey Neilan.

Gillette would later serve as the Army pictorial representative on Gen. Dwight D. Eisenhower's Allied Headquarters staff in North Africa and as photographic officer with the Fifth Army in Italy under Gen. Mark Clark.

The film unreeled showing workers buying bonds, farmers buying bonds, and city people lining up to buy bonds. The narrative commentary forcefully described the confident spirit of the American people. *"This was the people . . . the people on the march . . . it was the people's war . . . paid for by the people . . . the people had had enough, now they raised their voices . . . War Bonds were their voices . . ."* and so on it went.

The attending Army brass could be seen unexpectedly squirming and made quiet passing remarks to one another within their row. I could see something was not going well, but I didn't know why.

I noticed one Army general politely turn to a colonel seated beside him and then discretely ask him something. This colonel turned to our major, and while I couldn't make out what they were saying, I could tell whatever he said carried the phrase, "his name is O'Connell" at the end of it. I followed the thread of their conversation along with ever increasing worry as one voice yielded to another up the chain until I saw it could reach no higher. The mood in the screening room had become unusually quiet except for the narrative voices heard in the film itself.

The Army had begun to prepare qualified still and motion picture cameramen from the comfort of the SCPC studios in Astoria to cover the impending Allied invasion of North Africa, later known as Operation Torch.

I heard one senior Army general abruptly say to another, "Get him out of here!"

I could not believe my ears. Was it really me they were talking about?

A buzzer buzzed, the lights went on and the screening unexpectedly ended before the film had finished.

The visiting Army officers filed out briskly, followed by those of lesser rank.

The whole thing happened so fast that it didn't make sense. I was sure that my ears had played tricks on me.

I turned to our chief editor, Mickey Neilan, who was also wondering aloud what the hell had happened. He looked just as baffled as I.

Neither my section chief, Sergeant Mills, nor our major in charge let on to us that something was wrong.

Generals often make swift decisions and their decisions are carried out just as swiftly. That afternoon, Sergeant Goldberg, our section's First Sergeant, told me that he was cutting orders immediately transferring me to a Signal Corps combat photography unit that was heading overseas.

There wasn't much I could say. Goldberg did allow me the opportunity to see a Lieutenant Moore, who was then assigned as Colonel Melvin E. Gillette's administrative aide. Moore was nice and understanding but the official reason I was being sent overseas was that this unit of twelve men needed a "man of my immediate technical experience."

That was the official reason and that was that. Christ, I hadn't been assigned to the Astoria studios long enough in my opinion to get any real experience as a still photographer or motion picture cameraman that would have been useful to anyone.

I bid a reluctant farewell to the comfort of the Astoria, New York studios of the Signal Corps Photographic Center I had enjoyed for the past six months and prepared to ship out to Allied Force Headquarters, North African Theater of Operations, Tunisia.

I officially reported for duty as an official war photographer and posed for my official identification card signed by Major General, W.B. Smith, U.S. Army, Chief of Staff, Allied Force Headquarters, on April 25, 1943.

I was in the war at last.

One year and two months exactly from that time, I tried to bring up the matter personally with Colonel Gillette at Allied Forces Headquarters (AFHQ) in Caserta, Italy when I saw him again.

I asked the colonel who was then the highest ranking Signal Corps photographic officer in the Mediterranean theater if he could recall what really went on behind the scenes at SCPC after the screening of the war bond rally film which got me so quickly assigned overseas. Gillette's face registered a distinct blank. He didn't even remember me, let alone the specific incident that caused me so very much trouble. By then, I learned the Army's memory for unpleasant events is often very selective and convenient.

So from that modest beginning, I actually fell into the job as an Army motion picture photographer and thinking back upon that sudden shift of events, everything I could not have worked out better.

I guess in a way, I really owe it to old Colonel Melvin E. Gillette.

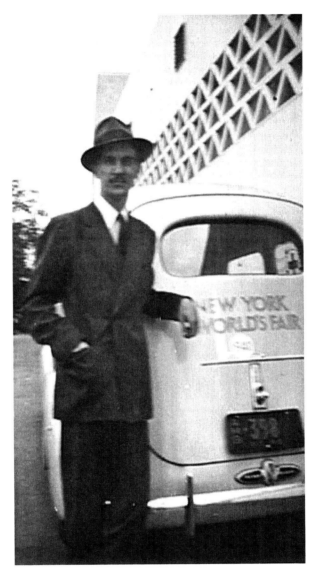

Burke O'Connell, then 24, at the 1938 New York World's Fair. Burke was a journeyman actor while living in New York and toured with the third New England Broadway road company of the popular play *Brother Rat* before the war. Hollywood actor and friend Gary Merrill, who later married well-known screen actress Bette Davis described himself and O'Connell in his memoir as "a pair of big shots among the extras."

(O'Connell collection)

Group of U.S. Army and U.S. Navy photographers assigned to the Pictorial Division of the Signal Corps. Army Signal Corps photographers include: Lt. Jack Judge, back row, left and co-author Edmund Burke O'Connell, back row, second from right. Donald Wiedenmayer identifies fellow Army photographers in the front row as Marshall "Sonny" Diskin, far left, and Danny Phillips, second from right, and Stanley Simmons, far right.

This informal group photograph appears in Army Col. Darryl F. Zanuck's wartime memoir, *Tunis Expedition*, recounting the landing of Allied forces in North Africa in 1942 during Operation Torch.

Army Pictorial Service, U.S. Signal Corps, 1943

A relaxed Burke O'Connell sits beside his love, Tina Calamai, 1944.
(O'Connell collection)

Tina Calamai is seated at left and her friend Rina is seated at right in front of the family dog, Giovacchino. The Villa Calamai is seen in the distance. The identity of other extended family members and children in the photo are not known.
(O'Connell collection)

A framed collage of O'Connell's own photographs, cut and assembled by him in the late 1970s, is displayed in the Rancho Mirage, California home of his surviving spouse, Jan Whitman O'Connell McGuire. The sealed montage includes candid wartime photographs of British Prime Minister Winston Churchill, and Allied Generals Dwight D. Eisenhower, George S. Marshall and General Charles De Gaulle, then leader of the Free French government-in-exile in North Africa.

—*Photo by Julie Whitman Jones*

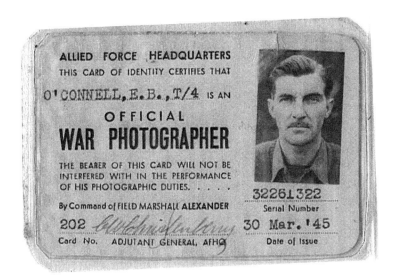

Identification card issued in March 1945 to Sgt. Burke O'Connell by Allied Force Headquarters directs field commanders to not interfere with him in the performance of his ongoing photographic duties. Burke took advantage of this official status to safely travel to and from the Villa Calamai when possible to see Tina while in the performance of his "official duties."

(O'Connell collection)

Embroidered shoulder insignia from the author's Army dress uniform identify his official duties as a U.S. war photographer.

(O'Connell collection)

CORPS EXPÉDITIONNAIRE FRANÇAIS en ITALIE

Campagne de Décembre 1943 - Juillet 1944

ÉTAT-MAJOR
1er Bureau

N° / CEF-1

ORDRE GÉNÉRAL N° 197

Le Général d'Armée Juin,
Cdt le C.E.F. en ITALIE

cite à l'Ordre DU REGIMENT

le T/4 Edmund B. O'CONNELL ASN 32661322 196th Signal Phot Compagny Ve Army U.S.

" Pour services exceptionnels de Guerre rendus en
" coopération avec les Troupes Françaises, durant
" la campagne d'Italie 1943-44."

Cette Citation comporte l'attribution de la Croix de Guerre avec Etoile de Bronze

P.C., le 22 Juillet 1944

French General Alfonse Pierre Juin, commander of the French Expeditionary Corps in the U.S. Fifth Army, issued the Croix de Guerre to Burke O'Connell as a regimental award for valor in recognition of his and fellow photographer John Mason's joint participation in a scouting patrol of the British Eighth Army to cross the Arno River by jeep into the city of Florence, Italy in July 1944 while under fire.

(O'Connell collection)

the only women were the ones he made out of those fresh-faced boys when he pinned their faces down to the hard cabin benches and made them squeal for their mothers.

As badly as Carl wanted that new sailor, he was a creature of opportunity more than desire. When the band stopped playing and the barflies started to pair off, he'd make his play for the sailor, and if luck went his way, he'd get the boy back onto the Akista under the usual lies about needing it refitted, or needing a hand with sailing and partying at the same time. If the boy seemed resistant to the idea—or if it seemed like he was going to be more trouble than he was worth—then Carl would just move right along to the next one. He could barely move in these bars for all of the off-duty sailors. It wasn't like he was going to struggle to find at least one to his liking who was dumb enough to fall for the spiel.

The night rolled on and the liquor flowed freely. There were very few things in his life that Carl had ever truly enjoyed rather than endured, but whiskey numbered second amongst them. And on that night, as on most nights, he went out of his way to enjoy it as much as was physically possible without it interfering in his other plans. If anything, the slur in his voice would just add credence to the idea that he was a fool with too much money to throw around, intent on partying his life away. Nobody expected to be outsmarted by a drunk man. Underestimation had always been one of the things Carl relied on. If he seemed like a stupid man, people would overlook the moments when he had outsmarted them as coincidences.

He had spent his whole life making sure to be overlooked just like that. Hunching his shoulders to look smaller. Keeping a blank smile plastered on his face when he was being insulted by people who thought they were talking over his head. He knew the secret behind the veil of the world. He didn't feel any need to draw attention to himself—aggrandisement like that just invited trouble. If it was up to Carl, he would cut through life like a shark through water, leaving not a single ripple behind.

It all paid off when the boy came and parked himself on a stool beside Carl without so much as an invitation. In between glasses, Carl had been putting his feelers out with some of the softer looking sailors, one who'd given him the predatory up and down glance and another who took such care of his uniform that it was starting to fray at the cuffs. Both, easy marks whom he would have settled for quite gladly if luck didn't go his way, but it seemed that tonight of all nights, the random forces of chaos behind the scenes were completely on his side.

'I heard you're looking for somebody to sail for you tomorrow. Somebody with a bit of experience.' It was all that Carl could do to restrain himself from laughing as this bald-chinned twerp tried to pass himself off as a wise old sailor. 'Now those two over there, they're good fellas, and God knows Tony could use the money. But from what I'm hearing, you need a touch of class. Got yourself a yacht, not some little dinghy, and you want somebody who not only knows how to run the rigging but can comport themselves properly in front of your guests. Those boys, I love them, and they could get your yacht running at a fair clip, no doubt about it. But, the minute you show them somebody from high society, they get themselves tongue-tied. They'd embarrass you in front of your fancy friends.'

Carl gave a sigh and masked the smile, fighting to get on his face with another sip of whiskey. 'Thanks for the warning, kid. Guess I'll keep looking.'

'No need for that, pal. I've got just the sailor for you, sitting right here.'

Carl made a point of looking past the boy, just to see how riled he could make him, but once again, the assumption was that Carl was the idiot, not him. 'No, buddy. Me. You want to hire me to run your boat for you.'

It wasn't often Carl got one so desperate to die. 'I'm not sure. Those other boys look like they've been out at sea a lot more than you.'

'That's the truth of it, pal, but all they've got is time on the steamers. They wouldn't know a mainsail from a rudder if you put them out on a yacht. Me? I've been sailing real ships since I was too young to piss over the side.'

Carl let a ghost of a smile through to dance over his face. 'Is that so?'

'It is. I've had more rope burns than those boys have had hot dinners, and if you want a real sailor on your yacht with you, I'm your man.'

Carl knocked back the rest of his whiskey and grinned as it burned its way down his gullet. 'All right then, boy, get your coat.'

'You mean it, mister?' Delight lit up the arrogant little bastard's face.

Carl shivered. He was going to love every moment of this. He was going to wring the happiness right out of that boy until there was nothing left but pain. Then he was going to make that pain look like a slap on the wrist. He smiled. 'I've got a bottle of the good stuff back on the ship, and I've got a spare cabin for you to sleep it off, too. Then you'll be all set for tomorrow. What do you say?'

'Sounds great, mister. Let me just get my stuff.'

Carl stopped him with an iron grip on the back of his neck. When he saw the first flicker of confusion behind the drunken stupor, he drew the boy in closer to whisper in his ear. 'Best you don't tell your little friends about this. Wouldn't want them getting their noses out of joint just because I picked you over them.'

'Right you are, mister. Don't want no ruffled feathers.'

Carl let his hand loosen, then slip down to pat the sailor's back. 'See you out front, then.'

Down on the pitch-black street, music could still be heard echoing out of a dozen bars and clubs along the way. Carl drifted along, trying to pick out a single tune in the pandemonium and coming up with nothing. Light streamed out from between badly fitted shutters, highlighting him for only a moment as he passed

by, his haggard cold face showing no emotion whatsoever. The boy from the bar caught up to him at a run. 'Hey, wait up there.'

'Wasn't going to leave without you, kid. Don't worry.'

The boy was fumbling in his pocket for a hand-rolled cigarette, and Carl took no small pleasure in blinding him with the flare of a readily offered match. The kid looked so young and innocent in that startled moment that Carl almost threw him down in the gutter and had his way with him then and there, tossing all his careful plotting and planning out the window just to get to that perfect moment of despair sooner. He didn't do it, because being impetuous had landed him in more than enough trouble in his time, but the temptation was real.

He slung an arm around the sailor's shoulders and guided him carefully along the cobbles, steering him away from any prying eyes or distractions. There was more whiskey waiting for the boy on the boat, better stuff than the rotgut they sold back in that bar. That was entertainment enough to get the little bastard on the hook. Then, once he was nice and floppy, Carl would do unto him the one thing in the world that he loved more than whiskey, with his fingers locked tight around the worthless little bastard's throat.

Come morning, the Akista would set sail, just as Carl had said in the bar. There was no lie in that. The only deception was in who would be at the helm, and what kind of cruise they would be taking. This little sailor boy would be down in the hold so that his smell couldn't offend Carl's nose, and their destination would be his favourite dumping ground for all the sailors he'd raped and robbed before. He never bothered to learn their names. It wasn't like any one of them ever lasted out the first night.

Born to the Mud

On the 28th June 1891, a boy was born in East Grand Forks, Minnesota—the eighth, and final, child of Prussian immigrants, Johann and Mathilda Panzram. To say that Carl was not as cherished as his older brothers would be an understatement. It wasn't that his parents played favourites, or that he was singled out for any particularly cruel treatment. They were simply exhausted. The pair worked day and night as 'dirt farmers' on an infertile patch of land that the family owned outside of Warren, Minnesota. As soon as a child was old enough to walk, they were set to work, too. At this point in history, land was still being parcelled out to migrants to the United States, and despite their lack of experience as farmers, Johan and Mathilda were intent on making their go at the American dream, a dream that grew ever more distant with each new mouth that they had to feed and each failed harvest that they had to endure.

Every one of Carl's seven older brothers had their chores to do around the farm, and it wasn't long before Carl was set to the same thankless tasks. The state mandated that all children must attend school from the age of five onwards, and Carl may have expected that to earn him a reprieve from farm work, but the time that he spent in education did not come out of the allotted

hours that he had to work on the farm. Instead, it was sliced off of his sleeping time, so that eventually he was down to only two hours, spending the rest of the cold night outside doing the hard manual work that had once occupied his days.

The lack of sleep and the hard work soon began to take their toll on the boy's health. For the first week of this treatment, Carl was merely exhausted, but from then on, his condition continued to deteriorate. His schoolwork began to suffer immediately, with every question posed to him answered only with a blank-eyed stare. Outside in the yard, his classmates struggled to get a response out of him when it was time to play, even when they tried to entice him out with his favourite game: Cowboys and Indians. Carl was like a dead man walking, barely 7 years old and completely lost to the world. The physical effects of this exhaustion followed on soon after his mental desolation. He developed a racking cough that never seemed to go away, along with a dozen other minor ailments that his family couldn't afford for a doctor to look at. After months of this routine, he developed a dangerous ear infection that led to swelling so pronounced, it left him deaf on one side. Even his typically negligent parents couldn't just leave him to go on in that state. As well as deafening him, the infection had affected his balance so badly that he was no longer able to walk straight. If Carl couldn't walk, he couldn't work, and that was an unacceptable state of affairs. Regardless of how ill he had become, the family's financial situation hadn't much changed, so his father decided that he would apply the expertise that he had developed working with farm animals on his own son.

The whole family gathered around the dining table one evening and held Carl's weakened and helpless body down as his father went to work in his ear with a kitchen knife, trying to excise the source of the infection as he would from an ulcerated cow. Every one of his brothers had to lay their full weight on top of Carl to keep him pinned in place as he squealed in agony and his father dispassionately sliced into him. It was only luck that

he passed out from the pain before his thrashing drove the knife into his brain. Long, wet minutes later, he was roused from his slumber by near-boiling hot water being poured into his ear to 'clean the wound', and this time even the strength of the whole family wasn't enough to hold him down. He scrambled free, screaming at the top of his lungs, and when one of his brothers tried to creep close enough to take hold of the boy again, he was answered with a fist to the face. Carl had lost all control over his temper since the first incision was made. His brothers would later claim that the pain had driven him into a frenzy, but the gruesome truth of the matter was that his father's inept attempts at surgery most likely encroached on his brain, in particular, the frontal lobe where impulse control is centred.

From that day on, Carl had a reputation for being wild and violent. Even the slightest insult would be answered with his fists. If the surgery had been successful, then this likely would have presented a more serious problem in the short-term before he learned to get his temper under control. But, as it was, the infection from his ear continued to spread until Carl had to be hospitalised for several weeks to recover. The cuts that had been made in his ear had allowed the bacteria to spread even deeper into his head, and it is quite likely that he suffered some inflammation of the brain during his stay in the hospital, resulting in a few minor seizures while he was laid up.

Eventually, he was returned home, but by then, things had already begun to fall apart for the Panzram family. The cost of his hospital stay had dragged their already faltering finances through the gutters, and brother after brother had found work elsewhere and moved on with their lives as quickly as possible. Carl became a terror around the household, completely uncontrollable by either one of his parents, and just as likely to lash out as to obey when given a task to do around the farm.

With no hope of keeping his dream of a thriving farm alive, Johann vanished not long after the latest of his sons, ostensibly heading out to seek assistance from distant relatives who had

settled further east, but really never intending to return. It left the farm completely devoid of capable labour and left poor Mathilda holding the bill for all the debts that were outstanding on the property. With help from the local community, and by portioning off large sections of her land for sale, she was able to keep the family home intact and out of the bank's hands, but it left them as paupers, scraping and scrabbling just to put food on the table and clothes on their backs. Every child who was old enough to work had abandoned ship at the first sign of trouble, and while Mathilda might have hoped for some support from the children she'd raised, the cold and loveless environment had not imbued any of them with a sense of sentimentality. She was on her own with Carl, and Carl was rapidly becoming a danger to himself and others.

The presence of Johann Panzram was the final seal on Carl's behaviour. Only the ever-present threat of his father's violence had kept Carl in line, even before he lost all control over his moods. But, with that restriction finally lifted, he began to behave precisely how he wanted to. His school attendance never recovered after his medical absence, with some spotty visits over the following months followed by perpetual truancy. With abundant time on his hands for the first time in his life, Carl roamed freely around Warren, taking in the sights and thinking things through for himself.

Like most places in the USA at the turn of the century, Warren was a town of extreme wealth side by side with horrific poverty, often just an easy stroll away from one another. Carl tried to puzzle through why some people had everything that they could ever want and others had nothing at all, but he was still too young to pull together a coherent philosophy to explain it. All that he knew for certain was that he wanted the things that the rich people had, and if he could find the opportunity, he was going to take it.

His first arrest came soon after. Not for burglary or larceny, but for public intoxication. He had been pilfering his father's

liquor supplies since long before the man fled the farm—taught how to pick the simple lock on the cabinet by his older brothers. But, since that supply had now dried up, Carl had taken to visiting the bars in town, where he'd been adopted by some of the local alcoholics as a kind of mascot. It was a situation that he'd try to cultivate again several times in his youth, but the amicable, almost familial relationship that he managed to maintain with those drunks, where they'd give him sips of whiskey for no more than his youthful company, was not one that could be found again once he was out in the world. The police picked him up initially for brawling in the gutter with a boy several years his senior. They were quite ready to chalk it up as youthful hijinks, but when it became apparent that he was drunk, they had no choice but to take him in.

After he was released back into his mother's care, Carl barely hesitated a moment before he was back down at the bar looking for his next drink. Alcohol made his painfully unfair life seem less unfair, and it quickly became a necessity for him to get through the day. The only negative effect of the alcohol, beyond the hangovers that were dwarfed by his regular headaches, was the lowering of his inhibitions. With his violent temper, having no barrier before he leapt into action was a danger to everyone around him. Luckily, when his lowered inhibitions did lead him into trouble, it was of the childish sort. He had often sat upon a hillock overlooking his neighbour's farmhouse—immaculately maintained and full of luxuries—and pondered what it was about them that made them so much more entitled to comfort than him and his own family. Now, in his slightly inebriated state, he came to the realisation that the only difference between him and them was that they'd taken what they wanted.

He walked right down into their house and let himself in through their open front door. Walking through to their kitchen, he stole a pie and an apple. If that had been the end to those 'youthful hijinks' then the law probably never would have gotten involved. He would've gotten a paddling from his mother and

been forced to apologise, but young Carl still had romantic notions about himself at that age.

He wanted to be a cowboy when he grew up, so when he spotted a revolver in a glass display cabinet, he gravitated towards it like a moth drawn to a flame. With the gun tucked in his belt and the pie under one arm, Carl made a run for home, delighted at his haul.

The police arrived shortly before sundown. They barely had to ask a single question at the other farmhouse before the identity of the culprit was obvious. Carl was known to the police as a troublemaker, and this time he would not be getting away with anything. The court intended on making an example of him, to keep all the other poor boys who might be tempted to take something from their betters in line.

The Painting Room

In 1902, Carl was passed into the care of the Minnesota State Reform School, the closest thing that the state had to a prison for children. It was a Christian facility, built around the principles of discipline and purity through flagellation.

On arrival, the 11-year-old Carl was ushered past the imposing concrete buildings and high fences to the cosy office of the warden, who insisted that all the children in his care refer to him as 'Father'. Once the door was shut and locked behind Carl, the warden began to question him about his homosexual tendencies. At the age of 11, Carl didn't have any. He had never even heard of homosexuality before that conversation, but he was about to receive a crash course including all of the gory details. Carl was stripped from the waist down, and the warden made a great show of carefully examining both his genitals and his rectum for any 'signs of sinning'. With the boy exposed, the red-faced warden began describing exactly what a predatory homosexual might want to do to him. This description soon went beyond words and into physical demonstrations of some of the acts. When Carl left his office an hour later, he was shocked into silence by the treatment that he had just received. It was only going to get worse once his induction was complete.

The bunks were spartan but no worse than Carl was used to, and his reputation as a brawler had preceded him, so none of the usual posturing was required among the other boys. Carl had no interest in making friends, and they had no intention of extending the hand of friendship to a scowling stranger who knew nothing about the way things worked here. He slept fitfully through the night, doing his best not to dwell on what had been done to him on the warden's desk. In the morning, a pair of the guards, dubbed 'helpers' by the warden, came to collect Carl and educate him on the ways that he would be improved while he was in their care. Before the sun had even risen, he marched out with them to the furthest edge of the compound, far from the warden's office, the street and any hint of civilisation, until they came to a squat wooden warehouse hidden out of sight of any passers-by. This was the place that would shape young Carl into the man that he would someday become. This was the Painting Room.

When he heard the guards describe it as such, Carl assumed that he was about to waste his hours learning how to whitewash or, worse yet, roped into some fruity art program, but he need not have worried. It was called the Painting Room because that was where the children were taken to have their bodies painted black and blue. The intention of bringing new arrivals to the painting room first was to shock them out of their old behaviours and give them a very clear indication of the treatment they would receive if they stepped out of line during their stay.

For the second time in as many days, Carl was stripped down to his bare skin. Next, he was fastened face down onto a wooden bench, then a threadbare towel soaked in salt water was laid over his back. The whipping commenced soon after. The belt that he was struck with had been specially made by a leatherworker to the warden's design. It was a broad expanse of leather, perforated all over with holes, similar to the ones you'd find on a regular belt, but with an entirely different purpose. Each time it struck the boy's back, it drew the skin that was pinched into those holes up into a blister, and when a blow fell

in the same place, those blisters would burst, and the stinging salt water would begin to do its terrible work.

For this first of many visits to the bench, the warden himself came to watch and bask in Carl's screams of pain. Every time Carl let out a yelp, the warden's face grew more flushed. He was loving every moment of it. From the second that Carl realised his captors were enjoying his cries of pain, he fell deathly silent. Even as it drove his torturer to strike him harder and harder, Carl still would not break and cry out. The brutal torments that were meant to beat all of the evil out of these boys had an entirely different effect on Carl. They beat all of the human weakness and empathy out of him instead. They hardened him into a man.

There was no time to rest after the thorough whipping was complete. Carl had to slip his dirty clothes back over his raw back and make his way to the morning classes. Classes centred exclusively upon Bible study and discussions of morality—although 'discussions' may have been too strong a term for rote learning and repetition of the viewpoints that the reform school was intent on imparting to its wards.

After classes, there was a brief break for lunch, then the children moved on to their work assignments. Because Carl had no useful skills to speak of, he was set to work in the kitchens, preparing the evening meal for the officers and the warden. On the first day in the kitchen, Carl went through his tasks mechanically, barely aware enough of his surroundings to palm himself something decent to eat later, but it did not take him long to realise how he might exact revenge on the guards. He urinated in any liquid that he could lay hands on and masturbated into the food at every opportunity, completely overlooked by the older boys who were meant to be his supervisors and the one guard who was stationed in the kitchen to ensure that none of the knives went missing.

Needless to say, Carl did not do well in his classes. He had no respect for the pseudo-religious leaders who were brought in to educate the boys, no faith to convince him that nodding along

with their platitudes was the path to Heaven, and no desire to show weakness in front of either the other boys or the guards. This led to him being dragged off to the Painting Room daily. His wounds never closed, and it was a wonder that infection didn't follow, given how rarely the children were given the opportunity to clean themselves.

The guards at the reform school took Carl's behaviour and attitude as a direct challenge to their authority. They viewed him as the one child that they could not break. So, they did the only thing that made sense to them: they tried harder. These guards were untrained, with no screening or education required as there would be for an actual prison guard. The turnover for new guards was astronomical when they first learned what their tasks would actually entail, but the ones that stayed were there for life, and the stories that they spread about the local community attracted all of the other uneducated sadists in search of employment to the reform school too. These were the kind of men who, when given the job of beating young boys into submission, not only failed to shy away but grew excited about the prospect. Yet, even they found themselves out of their depth in the face of Carl's stoicism. No matter what they did to the boy, they could not break him, and more often than not his Painting Room sessions ended not because the boy could take no more, but because his torturers had become too exhausted to continue.

In the face of this challenge, the warden dipped into his deep pockets and commissioned a new piece for the Painting Room. Not mere leatherwork this time, but a whole crank-operated paddling machine that would take all of the labour out of beating children into submission and godliness. But, while it certainly took the effort out of the enterprise, it was considerably less effective than the strokes administered with human malice behind them. The very consistency that the machine was built for proved to be its greatest weakness. Every impact that it doled out was identical in force and placement, with no variation to prey on sore spots or the psychology of the child. The Painting Room

sessions could go on for even longer than before, but they proved utterly useless in breaking Carl, and their effectiveness on the other boys saw a marked reduction too. While some blamed this on the new machine, the warden remained quite certain that the faltering discipline was a result of young Carl's defiance. In the warden's mind, the other boys were looking to him as some sort of hero for remaining stalwart in the face of so much pain, and they were drawing their own rebellion from reverence of him. It could not stand, so the warden began taking a personal interest in Carl's punishments once more, shuttering himself up with the boy in the Painting Room and adding new depths of sexual humiliation to the nightmares that he was already having to endure on a daily basis.

Throughout all of this, Carl was still making his little additions to the officer's food and drinks, without attracting the notice of anyone. The warden himself tended not to eat in the mess with the others, preferring his own refined company and meals made by his wife. But, when he decided one evening to bolster morale by sitting with his men, Carl finally saw his opportunity for more direct revenge. Rather than pissing or masturbating into the old man's meal, Carl instead located the kitchen's supply of rat poison and poured in a hefty dose. It marked the first time that Carl deliberately tried to murder another human being, an act that he had been driven to by the endless brutality he was subjected to, along with his own unending rage. But, while all of his more bodily additions to the meal went unnoticed, his supervisor in the kitchen spotted the open rat poison and stopped the coffee from going out.

After Carl was reported for this attempted murder, he was removed from kitchen duty and instead set to keeping the compound clean, indoors and out. There was some intention to punish the boy further, but the guards and warden had reached the limits of their imagination when it came to new tortures to inflict on him. They were already doing the absolute worst they

could to the boy, and all that it was doing was making him angrier.

Carl began to learn some moral lessons while he was attending the reform school, but they certainly weren't the lessons that were being taught in class. They were the practical messages that he was receiving every day while he was strapped down to a bench and beaten with the full strength of a dozen grown men. The strong preyed upon the weak. That was the fundamental truth that Carl could not get out of his mind. The guards were stronger than he was, and that gave them the right to inflict whatever torments they wished on him for as long as he was in their power. But, Carl was not the weakest one in the camp. Far from it. There were younger boys than him in the school, and even the boys several years his senior couldn't stand up to him in a fight. He was stronger than them, and they were afraid of that strength. He might not be able to get his revenge on the guards or the warden, but those other boys—those weak children—they were an easy outlet for his fury.

At the time, there was a philosophical precept still in wide circulation. A mixture of pure self-interest and the larger overhanging ideals of imperialism and the divine right to rule. While the Christian reform school taught the more abstract version that revolved around God giving the people who would make the right decisions the power that they needed to rule, citing any number of Biblical kings in support of the idea, Carl was able to boil it down to the more fundamental truth that adults often bandied about when they thought impressionable youths weren't there to absorb their bad lessons: might makes right.

He bullied and beat the other boys to within an inch of their lives, took his punishment for stepping out of line without flinching, and spat in the face of authority at every turn. The warden, incensed by this outright rebellion and further proof of Carl's 'fundamentally evil nature', upped the punishments that Carl received until he spent almost every working hour being

smacked around by shifts of guards in the Painting Room. His own workload was pushed into the night, on the assumption that exhaustion alone would prevent him from acting on his evil impulses. But Carl, already accustomed to living on only two hours of sleep, was as immune to this torture, as he had been to all the others. The end result was that he had free reign to roam the compound at night, almost entirely unsupervised. Supposedly, this was so that he could do all of the cleaning that he had failed to get to throughout the day, but with nobody watching over him, it rapidly turned into playtime for the young boy.

As much as his education in non-moral subjects was lacking, Carl still possessed a fierce intelligence, and it did not take him long to work out that the cleaning chemicals that were freely doled out by the guards were actually extremely dangerous substances in the wrong hands, and his hands were most assuredly the wrong ones.

Using paint stripper and the like as accelerants, he committed his very first act of vengeful arson in the dark of the night. There was nobody in the Painting Room when he set the fire, although given how ready Carl was to poison the warden, it seems unlikely that the thought of murder was abhorrent enough to slow his vengeance.

The warden was absolutely furious about the fire and the destruction of the speciality items that he had crafted for that room, but he had no way of proving that it was Carl, or even that it was arson—not without involving the local fire department and bringing unwanted scrutiny to the practices of the reform school. Among the prisoners, it was hardly a secret that Carl was the one responsible for destroying the loathed Painting Room, and while he had earned the respect of the older boys with his unbreakable nerve and readiness to fight anybody, he now had their gratitude. Some of the 'upperclassmen' pulled him aside after lunch one day and began coaching him on how to get paroled out of the reform school. This was where Carl learned the second valuable

lesson from this period of his life: people will believe any lie you tell them as long as it is what they want to hear.

The next morning in classes, he was attentive and polite to the teachers, parroting back, without delay, whichever piece of dogma they were doling out. But, more than merely performing adequately, Carl seemed intent on excelling. He would ask leading questions to draw out more complex answers to moral quandaries, he would show real insight into the subjects being discussed, and most importantly of all, he began to show real signs of having adopted the faith as his own.

Carl's conversion was the talk of the guards, and his whole attitude and demeanour towards them changed as he let the lessons of humility and obedience guide his actions. Within a month, the Warden was delighted to sign his parole papers and send him back out into the world, brimming over with pride at the change that his methods had wrought in the boy.

That pride was ill-placed. All that Carl had learned from the experience was an absolute loathing for his fellow man, that the strong preyed on the weak, and that lying would get him whatever he wanted.

Off the Rails

Carl returned home into his mother's care at the age of 13, at the beginning of 1904, and he was immediately pressed back into service on the little patch of farmland that the family had left. Only he and his mother remained of the Panzram family, with all of his siblings cutting off contact as their mother's pleas for financial aid became more persistent and desperate. The only one of his brothers who'd remained to help out on the farm had died in a tragic drowning accident while taking a swim in a nearby pond, just a few short weeks before Carl's return home. His mother, never in the best of health, had taken to her bed almost immediately afterwards, leaving the whole farm to fall to ruin, unattended. Without some semblance of care, the fields had become overgrown, the crops had turned to rot, and the few animals they'd managed to scrounge up the money for were on death's door through starvation and mismanagement. Everything was falling apart, and Carl was absolutely delighted to see the destruction of a place and family that he had always loathed, with as much passion as he had ever been able to muster for anything.

Now that he had found his freedom once more, Carl had no intention of wasting it pushing dirt around for the rest of his

days. He put as many animals as he could justify out of their misery, sold off the survivors and deliberately tore up any crops that looked like they might have a chance of recovery. The sooner that the farm died, the sooner he would be free of this miserable line of work for good. As the place slipped further and further into decline and more responsibility was heaped on his shoulders, Carl began returning to his old haunts around town so that his mother couldn't find him, rediscovering the joys of liquor and coming to the unfortunate realisation that the cuteness of an alcoholic kid was considerably more potent in mooching drinks than the cuteness of a surly, hard-drinking teenager.

He frequently stole money from his mother's purse to fund his drinking, but there was very little there to be had, so it didn't take long before he was committing low-key muggings on his old school mates for their pocket change. A Native American boy, who was already outcast in the town due to his ancestry, soon fell in as his accomplice, and with an increase in muscle, their operation got even more fearless. Carl wouldn't just rob the men that they took hostage, but he would also strip them naked and set them off running afterwards. He was not yet a rapist, but the delight that he took in sexually humiliating these boys and men was a sign of things to come. It seems likely that if he hadn't had his accomplice standing in judgement, then he would have gone further, but as it was, he had to maintain at least some appearance of civility to maintain the relationship. Deep inside, Carl knew that nobody would accept him if he let his true animal instincts come out, so he practiced the hypocrisy and deception that the reform school had taught him so well—always acting as though the torments that he inflicted on his victims were merely to shame them too badly for them to risk talking about their young muggers; a course that actually proved surprisingly effective. No man wanted to admit that a pair of teenagers had stripped and robbed him with just the threat of violence, laughing all the while.

His mother grew fearful over the course that her final son's life was taking. She didn't know a fraction of the crimes that he was committing, but she saw the money in his pockets and smelled the liquor on his breath. Something untoward was going on, and she needed to put a stop to it before it destroyed them both. Eventually, she managed to corner him one night before he slunk out to the bars and demand that he make some decisions about his life.

She was equal parts stunned and delighted when he announced that he wanted to be a priest. He claimed that he had found his calling in reform school—which was true, in a sense—and that he was incredibly bored doing farm work when he felt like there were so many more important things that he should be devoting himself to. Mathilda wrote a letter to the local seminary that very night, begging for her son to be granted admittance and also for some sort of bursary for the cost of his educational supplies. She was nothing if not consistent.

To the pair's delight, they received a welcoming letter of invitation for young Carl to begin his studies immediately, and before a week was out, he found himself cloistered in the safe and quiet world of academia, where his excellent memory and ability to assume any moral position for the sake of an argument soon made him well-liked amongst his peers and tutors—all but one.

A German Lutheran priest was a guest lecturer at the seminary, and where others saw Carl's wit and charm, he saw through the thin façade to the emptiness beneath. He did not believe that Carl had any faith nor any of the moral values that he espoused at the drop of a hat. So, he set out to prove it. He established himself early on in Carl's education as some kind of academic adversary, quizzing and grilling him constantly, pushing the boy to slip up in any of his rhetoric or arguments so that he could denounce him. Carl was able to match wits with the man for a while, but his temper was riled, and it didn't take long before the civil rebuttals that he was able to produce in the early days turned into screaming arguments. This sign of poor

temperament was exactly what the Lutheran had been looking for. It went beyond adversarial conversation and into a lack of discipline, something that the seminary had only one punishment for. Corporal punishment.

Carl's quiet days at school soon became punctuated by daily beatings from the German, and it left him enraged. How dare this priest treat him that way when he was telling every lie exactly how he was meant to tell them? Didn't the old bastard understand that this was how it was meant to be? You told the right lies at the right time, you said the words that they wanted you to say and people obeyed you. That was how the church worked, so why wasn't it working with the Lutheran?

Carl had continued to commit some minor robberies while he was in the seminary to keep him in drinking money, but he found burglaries to be the easiest way to get what he wanted. People around Warren still left their doors unlocked all day. It was a quiet little country town with no suspicion, full of friendly neighbours who would help you out how they could and would expect you to return the favour in kind—a prime hunting ground for a boy like Carl. In his thievery, he had acquired only a few items of real value beyond the change that he scooped out of people's pockets, but prime amongst those cherished objects was a Colt revolver, which one of the local farmers had kept hidden in a box under his bed. Carl carried it with him everywhere he went, enjoying the feeling of power that the lethal weapon gave to him, and having no trust that his mother wouldn't dispose of it if given the opportunity.

On what would become the boy's final day in the seminary, the Lutheran priest confronted Carl after class one day, demanding yet more proof of his understanding of the material, and resorting to violence soon after when it seemed apparent to him that Carl's rapid but curt answers were another sign of insubordination. During the ensuing beating, the pistol fell out of Carl's jacket and landed on the floor. Both man and boy froze for an instant, staring at the deadly piece of metal between them.

Then, without hesitation, Carl scooped the pistol up, cocked back the hammer, aimed it right between his tormentor's eyes and pulled the trigger.

The Lutheran was stunned into silence. The only noise in the room was Carl's ragged breathing and the gentle click as the hammer came down over and over to no effect. The gun had been disused for far too long in its lockbox beneath some farmer's bed. It had never been maintained, and now its inner workings were jammed. Still, Carl's fury would not abate. He went on pulling the trigger as the weapon clicked uselessly until he was tackled by a pair of the other teachers who had come to see what the commotion was.

Nobody wanted the police to get involved, least of all the Lutheran who would have to explain how he drove some God-fearing country boy from wanting to be a priest all the way to wanting to be a murderer. Carl was taken aside by the rector and was treated to a quiet conversation about his future and the ways that he was an ill-fit for the solitude and tribulations of the priesthood. There was no judgement, only the gentle suggestion that the boy should pursue a career elsewhere. In the end, Carl's only punishment for attempted murder was the loss of his prized pistol, and that had proven to be ultimately useless anyway.

Mathilda did not notice that her son was no longer attending school each day, as he instead took up his old habit of roaming around town, looking for trouble. What she did notice was when the bursary stopped coming in. That was when she confronted Carl about seminary and the truth came out. She loudly proclaimed her disappointment in him, but that was hardly new, and announced that he would be returning to work on the farm the next day if he still wanted to sleep under her roof. It seemed far too steep a price to pay for Carl. He packed up his sparse belongings and left the same night.

In those days, travel across the states, and indeed the world, was an entirely different prospect from what drifters of future generations would have at their disposal. The roads were mostly

dirt tracks, the number of cars on them could be counted on your hands, and those were curiosities more than practical transportation. Hitchhiking was out of the question. Horses were still considered the most viable means of transit locally, and for longer distances, it became necessary to board a locomotive. The American railroads were expansive, expensive and a major feature in the daily workings of the nation. As such, they were fiercely protected by railroad 'bulls'; private security armies of the rail companies whose primary mission was to ensure that nobody interfered with any of the cargo and that absolutely nobody stowed away on the trains.

Despite their diligent attention and violent responses, the bulls could not catch every single transient who hitched a ride in the box-cars, and whole subcultures of transients existed in those days who made use of the trains as their primary means of transportation. Some were itinerant workers who had to travel to find work. Some were the regular homeless people who would take work if they could get it but had no real interest in being part of mainstream society. The mentally ill were also well-represented, chased away from their homes by a society that had little-to-no grasp of any mental disorder beyond 'criminality'. There was a real criminal element who were also well-represented among the transient population: those who choose that life, and those who were driven to it because of their proclivities being incompatible with a civilised society. Unfortunately for a young man setting out into the world for the very first time, the distinction between those groups was blurred. Carl had not learned the signs that distinguished one from the other, and soon he fell prey to his ignorance.

His first few encounters with the transient community had been mostly positive. Carl kept mainly to himself unless he was invited to share in the bottle that was being passed around to stay warm, and that endeared him to the more insular tramps and hobos who didn't appreciate anyone prying into their lives. There was some sympathy for Carl, too, driven to this travelling life so

young and innocent. It was the sort of kindness and camaraderie that he had only ever experienced in the bars back home, and it soon conditioned him to accept any other homeless person that he came across as friendly.

When he snuck aboard a box-car hitched to a train that was headed for Nebraska and encountered a group of four middle-aged homeless men, he didn't give it a second thought. The men seemed startled by his presence at first, but once the train got rolling and they had all settled on the straw bales, the conversation got flowing all over again. By their account, the four were friends who had been riding the rails for many years together, sharing all the small pleasures that were available to men of their station equally, but they were more than willing to share a little with the 14-year-old Carl, too. First, a bottle of whiskey was passed around, which Carl was delighted to indulge in alongside the rest of them, but then the evening took a more sinister turn.

'Listen kid, there is a thing that we all like to do together. Something that feels real good, and we think you'll enjoy just as much as we do.'

They began untying their rope belts and easing out of their ragged and filthy clothes to expose bodies that were barely any cleaner. Carl had received his thorough education in the evils of sodomy more than a year ago, but the recollection suddenly reared its ugly head as he saw the predatory look on their faces. 'I'm not so sure, fellas. Why don't you all just go ahead and do it yourselves. I won't pay you no mind. Think I've had enough fun for one night.'

'Well, kid, it doesn't really work like that. See, you're kind of the centre ring in this circus. You're the one we all want to see.' They crept closer, pale and monstrous in the moonlight streaming in through the cracked box-car door.

Even if Carl had been capable of backing down, a short life of conflict with men like this had taught him that showing

weakness was never the way to go. 'I told you, no. I don't want nothing else. Got it?'

'Oh yeah, kid, we've got it. But you're the one that's going to get it.'

They pounced on Carl all at once, ripping at his clothes until he was naked as the day he was born, then bending him over the hay bales. It took three of them to hold the bucking boy down as the first man came up behind Carl to take his turn, and even once the man was inside him, tearing him up and drawing ragged gasps of agony out of Carl, he still didn't stop fighting. All through that first rape, then the second, third and fourth, Carl tried to fight his way free, biting at their hands when they came close enough, kicking out feebly at whichever man was behind him. It was all for nothing. They took turns on him all through the night until his blood and their fluids were running freely down his thighs and he was too exhausted to move another muscle. They tossed him out of the moving train just before they arrived at the next stop. They'd seen how much fight was in the boy, and they had no intention of sleeping with him anywhere near them. But paederasts and rapists though they were, they still stuck to the code that governed transients outside of those proclivities. They tossed Carl's sparse belongings and ripped clothes off along with him. Thievery wasn't their way.

It wasn't until the next morning that Carl came back to an agonising consciousness. He was lying in a field by the side of the rails. His few belongings had burst out of his pack and spread out around him like an explosion had gone off. Every time he tried to move, a new sharp spike of burning agony shot up inside him. When he groped, weeping, at his backside, he found it crusted with blood and worse. He lay there holding himself until he could draw a steady breath, then he dressed himself, scraped together what little he had, and started the long, slow, arduous walk to the nearest town.

All that Carl had learned about cruelty before now had been at the hands of other men, and in that box-car, surrounded by

the musk and heat of those vile men, he had learned a whole new lesson. There was more pleasure to be taken from others than just the satisfaction of vengeance or the delight of superiority. Their flesh could be a source of delight, too. From that moment on, he was a devoted advocate of sodomy, and a growing interest began to develop in him in practicing it for himself, from the position of ultimate domination. He had never been more humiliated than when those hobos took their turns on him, never felt weaker or more worthless, not even when the warden back at the reform school had given him his extensive examination. The thought that he would be causing the same kind of suffering and terror to his victims that he himself was currently experiencing just made the possibilities so much sweeter. Just as he had passed on the pain of his beatings at reform school to the younger, weaker boys, so too would he pass on the horrors of this gang rape to anybody he could lay his hands on.

From then on, Carl was much more careful about the situations he allowed himself to end up in. He took the measure of every group before he came near to them, and he was increasingly suspicious of any sort of kindness. He began to see his own nihilistic worldview of the strong and the weak as maturity and assumed that anyone who had more experience of the world than him was further down that same path, ready to lash out and prove their dominance at the drop of a hat. It was an assumption that kept him safe but also cut him off from any possibility of normal human contact. He moved through life like he was surrounded by predators just waiting for their opportunity to turn on him. His intention was to turn on every one of them first. He would never be fooled again by kindness, real or feigned.

Even with this new lesson burned into his mind, his internal injuries had barely healed before he suffered another brutal sexual assault. No matter how clever or careful he was, Carl was still a 14-year-old boy trying to navigate a world full of roaming criminals who preyed on children just like him.

The transient community had very few gatherings, always doing better when they spread themselves thin and avoided attention, but the tent-cities that sprang up in rural areas where there were rumours of work were unofficial convening points for them. A place where they could trade the latest gossip and guidance, direct each other to juicy places just waiting to be robbed, or just share some rare and precious time in the company of humans who didn't look on them as being the equivalent of roaches. Carl had been avoiding these gatherings for most of his time on the rails, but sobriety was beginning to take its toll on him, and he knew that there would be rotgut whiskey passed around and no awkward questions about his age being asked at one of the bonfires scattered far from the city lights.

He picked out a small mixed group and mingled very carefully, taking care to keep to himself as much as possible and drink only as much as it took to keep him comfortable. As the night went on and the crowd thinned, Carl fell into a deeper conversation with a young man who seemed almost comically interested in everything that he had to say. There was a bottle of rotgut resting between them and a pleasant warmth emanating out from the fire when the subject of sodomy was subtly broached. The man was asking about Carl's experience with it, not as a threat or to launch into some rant about sin, but as a flirtation, as a prelude to the closest thing that Carl would ever experience to a sexual relationship.

With Carl's interest piqued, his new friend led him off towards a broken-down barn that some of the tent-city residents had cannibalised for firewood, far enough away from the main camp that they wouldn't draw any attention if they made a noise. They went on swigging from the whiskey as they went, as Carl's new friend insisted that it would be easier and feel better if they both got nice and loosened up. They agreed to take turns, so both young men could experience both sides of the equation, but when Carl insisted on going first, his new friend called out to a

group of his older friends and they encircled the now thoroughly inebriated boy. Carl's only consolation was that he was drunk enough to pass out before they were finished passing him around. Afterwards, he woke up under a flap of canvas with all of his belongings tucked in safely beside him. This time around, the pounding in his head was more of an impediment than the aching in his backside. All that this second lesson did for Carl was cement the idea in his mind that sodomising boys must be one of life's great pleasures if so many men were desperate to do it.

The Trail of Ashes

The long journey to the East was easily reversed—far more trains were running out to the West with supplies than the other way when there were no harvests to be dispersed. While he may not consciously have had any intention of running home with his tail between his legs, that was certainly the direction that the boy was headed. Carl's reluctance to travel with other transients had grown to an aversion following his second rape, but without the support structure of others in his position, he became increasingly reliant on theft to put food in his belly and whiskey in his veins. The only time that he would willingly approach another hobo was when he was certain that they were alone, and even then it wasn't for the purpose of socialisation. Just as Carl had been raped, so too did he now begin to rape others. Once again, he managed to lay his hands on a gun during one of his many robberies, and with that gun came some confidence. When he found the opportunity, Carl would approach pairs of men travelling together and force them to have sex for his amusement at gunpoint. He was once caught by a brakeman on a train in the midst of raping another man in one of the box-cars, only to turn around and force the hobo to rape the railway worker instead before taking his turn with both of them. With a gun in his hand

and a sneer on his lips, Carl was fucking his way back to a feeling of power.

Still, his campaign of robberies continued, and he was barely back in Minnesota before the police picked him up on a larceny charge. Unable to accurately gauge the boy's age because of his emaciated state and sympathy to the poor boy's plight as a homeless child who was likely a lost orphan, it was decided that Carl would be best corrected in the Red Wing Training School.

Compared to the state reform school that he'd been consigned to before, Red Wing was a paradise for Carl. They were set to hard physical labour throughout the day, working the school farm, but it was nothing that Carl hadn't done in his sleep before. He was immune to the exhaustion that infected all of the other boys and made them weak, just as he was immune to the petty corporal punishments that the guards doled out to him when he was defiant. It was like he didn't even feel the few half-hearted beatings they doled out.

Red Wing was more of a school than a prison, based in lush woodlands far from the bustle of civilisation and the associated temptations, with an actual education program at work that Carl had no trouble passing through, something that the other boys—with their minds numbed from the exhaustion of arduous hard labour—could barely even comprehend.

The perception of Red Wing's administration was that Carl was a young man who had been through a rough patch in his life and just needed a little guidance to get back on the right track. The perception of the other boys was something entirely different. Carl had graduated from being a bully to being a predator. Anything that he wanted from another boy, he took. And he wanted everything. At Red Wing, Carl's sexual awakening finally came to fruition, but every act that he committed to the boys around him in the dark of the night came with the threat of violence and shame. It cemented in his mind that sex was a product of that violence and that pleasure could only come at the expense of someone else's pain. Those that he raped never came

forward about it, dreading the ridicule that they'd receive. But, before long, the defiant rebel who could have been a rallying point for an uprising against the guards became a complete pariah. Everyone knew what he had done, everyone knew what he was, and everyone was terrified that if they caught his eye, they might be next.

All of them except Jimmy. Jimmy was a slightly built 15-year-old, presenting no physical threat to the already surprisingly powerful Carl. While all the others shied away from him, Jimmy seemed quite content to just chatter away at him as if there were nothing wrong. The two soon became inseparable. It is likely that Jimmy was attracted to Carl and wanted to pursue a relationship while they were confined together, having already heard about his sexual reputation, but Carl didn't have any basis for comparison to understand what a healthy relationship might look like. For him, sex was exclusively about violence and domination, so the idea of inflicting it on his only friend in the whole world seemed ridiculous. Despite Jimmy's lack of physical prowess, he brought a fresh perspective to Carl's life and allowed the duo to secure a comfortable position for themselves within the reform school's hierarchy.

But even this position of comfort, probably the greatest that Carl had ever experienced in his life, was not enough for him. There was a rage in Carl that could not be calmed by any amount of easy living and readily available sex. Whiskey and sodomy may have been his greatest delights in life, but vengeance was his true passion, and there was a whole world out there beyond the fences that marked the boundaries of his confinement that he wanted to get even with.

Working together with Jimmy, who lacked Carl's raw intellect but had considerably more patience, they were able to formulate an escape plan—the first of many jailbreaks in Carl's life. Under cover of darkness, the two of them stole away from the school and headed out into the wilds, far from the prying eyes of civilisation. When they finally returned to humanity, it was

with a mission of vengeance in mind. One that would prove quite profitable for both of them.

The community where Carl grew up wasn't much more devout than any other at the time, but even so, it had been easy for him to see first-hand just how much cash was slipped into the collection plate each Sunday, with the poorest farmers typically throwing in considerably more than the richest. Nowhere in the rural communities that they began striking was there more of a concentration of wealth than in the churches, and nowhere was Carl's rage more easily directed than towards Christianity and all of the many rapists, sycophants and liars he upheld that dwelled amongst the ministries of America. In the dark of night, the two boys would break into the empty churches to pilfer anything of value. Then, when their work was done, Carl would gather up whatever supplies he needed from within the church and set the whole place alight. They left a burning trail behind them as they hiked from town to town, church after church incinerated down to the foundations and a small fortune amassed in their packs. Enough wealth to allow them some sort of settled life if they wanted it. Not that they wanted it.

Carl and Jimmy were a match made in heaven, and they were almost entirely invisible to the police thanks to their constant movement. There was very little communication between the neonate law enforcement agencies of the time, and just by drifting along from town to town they managed to avoid detection for almost four months, despite the theatrical quality of their crimes.

Unfortunately for Jimmy, their luck couldn't last forever. He was caught trying to fence a pair of candlesticks that had been stolen from one of the churches and arrested for larceny while Carl dozed back at camp, waiting for his friend to return. It was only days later when he finally braved town that he learned what had happened. By then, Jimmy had already been shipped off to an adult prison to serve out the remainder of the sentence he had dodged back at Red Wing and the new sentences that had been

heaped on top of that for his crime spree. He would never see the light of day again.

Carl was despondent and aimless following the loss of his friend, but what he lacked in company he more than made up for in pocket change. He started riding the rails again, fleeing in part from the law but also from his memories. As far as he was concerned, nothing good had ever happened in Minnesota, and he had no intention of spending another moment in that state if he could avoid it. He roamed across the states for several months without leaving any sign of his passing, studiously avoiding any of the other transients who crossed his path; he had no intention of sharing even a single penny of his takings with them. Where before he would stick to the small towns and rural communities to avoid any risk of drawing attention to himself, now he had learned some of the potential benefits of large congregations of unsuspecting strangers. He whiled away his time in the bars of a dozen cities across nearly as many states, bouncing along before anyone could learn his name. He crossed the border into Kansas at about the same time that he rolled into his fifteenth year of being alive.

It was there, in Kansas, that the money dried up, and it was there that Carl, deep in his cups, decided that he needed to find a new purpose in his life. A new meaning. He knew that he enjoyed violence, suspected that killing would be the next great thrill for him to experience, but he was also still a child, attached to romantic ideas about himself, and clinging to the hope that he could become somebody just as legendary as the cowboys he had heard all about. The Indian Wars were still raging in the West, with the Native Americans portrayed in every piece of media as vicious savages in desperate need of tough men to drive them into the oblivion that they deserved. Carl couldn't be a cowboy gunslinger like he'd always dreamed, but he could certainly take the fight to the Native Americans if he signed up to the army. There were recruitment stands dotted around everywhere that he went, and the idea had been preying on him for some time.

He would have to lie about his age to get in, but that was hardly a burden on his conscience compared to everything else that he had done.

He showed up to the recruiters still drunk from the night before, and they were more than willing to take down his name. By the time he'd sobered up, Carl was in boot camp and already starting to regret his decisions. The same resilience that had gotten him through his prison experiences came to the fore, impressing his superior officers. He excelled in his weapons training as much as in physical activities thanks to his relish for them, but he seemed almost entirely incapable of taking an order without having to be browbeaten. His rebellious streak remained unbroken after all of these years, and it soon overshadowed any good work that he was doing in training. There was a split opinion among the officers. Either Carl was leadership material with the drive to lead lesser men into battle or he was a young thug with no respect for the chain of command. Neither of these viewpoints fully encompassed the truth of Carl, but in the end, it didn't matter one way or the other.

With wages being paid out to new recruits rather more slowly than Carl would have liked, he became uncomfortably sober in the evenings, and while he usually would have indulged in his second favourite activity, the army was on the lookout for any sort of hanky-panky going on in the barracks. Worse still, most of the men with whom Carl was training were considerably older and stronger than him, having made the decision to join the army with a little more forethought and planning about their prospective futures. He wasn't certain that he'd be able to force any one of them into the kind of sex that he'd enjoy, so his frustrations began to bubble up. He snuck out of camp once or twice to spend the last of his savings on liquor, but his money ran out as fast as his welcome. Within only a few days, he had nothing left, and the cold dawn brought a hangover to end all hangovers with no hope of the hair of the dog to ease it. Something had to be done.

The next time he broke out of camp, it was to conduct some business rather than indulge in his pleasures. He located the local fence and grilled him on what he would consider to be the most valuable objects in the military base. With a few target items in mind, Carl went back to his training the next day with a plan already crystallising in his mind.

Less than a week after his training began, Carl was caught sneaking off the base. For all the successes that he'd had robbing unoccupied churches, he really wasn't much of a thief, relying perpetually on luck to carry him through rather than developing any sort of useful skills in that area. In itself, sneaking off would have just resulted in some relatively minor punishment, docked wages and unsavoury duties to perform. But the fact that he had a gunny sack full of army uniforms that he was planning to sell for illicit purposes served to complicate matters. Larceny was a criminal matter, and stealing $88 worth of material from the army was tantamount to treason. Even so, it was apparent to his superior officers that Carl had made a foolish mistake, of the sort that are ever so common among the very young; they did not know the appropriate way to punish him for the transgression. Luckily, being a part of an army comes with a very simple solution when you are confronted with a problem that you do not know how to solve: a chain of command that questions can be passed up until they reach someone who either knows the right answer or has enough clout that choosing the wrong answer won't harm their career. In this case, the question was passed all the way to the top. The buck stopped with William Howard Taft, the then Secretary of War for President Theodore Roosevelt. Taft took one look at the case and made a split-second decision. This Panzram boy would be an example to any other men who thought they could cross the United States military. Despite his youth and the relatively minor nature of his offence, Carl would be dishonourably discharged from the army, and he was then to serve the maximum sentence possible for his crimes in Fort

Leavenworth, which was widely considered to be the toughest prison in the whole of America.

After months of waiting in the brig for a sentence to be passed down—months when he was constantly reassured that everything was going to blow over as soon as somebody with enough pips decided to drop the matter—Carl was incensed by Taft's decision. He cursed the man and swore revenge, even though the idea that a mere boy could be any threat to one of the great men of the nation was laughable to those around him. The court-martial was brief and to the point, not really a trial so much as a passing down of the two-year sentence. Then, Carl was sent off.

Fort Leavenworth was all that it had been promised to be and more. As a military prison, every man serving time there had been court-martialled and dishonourably discharged from an Army that would tolerate almost any kind of ill behaviour on the part of its soldiers at that time. The guards often gambled on the lifespan of new arrivals. Nobody gave Carl particularly good odds. He may have been well-built, but he was still only 16 years old, while the rapists, murderers and hardened criminals that filled the prison from wall to wall were adult men who were well-accustomed to violence. While the murder and torture of their fellow men did not offend those ex-soldiers, trumped-up stories about Carl's theft and status as a 'traitor' made many of them thirst for his blood. Solitary by nature, Carl had neither the social skills nor the inclination to join up with a prison gang, so the first few weeks were brutal. Carl survived just as he always had, by showing no sign of weakness or fear in the face of the pain.

The very behaviour that had made Carl a hero during his last prison stay made him a pariah in Leavenworth. Prisoners were divided up into companies, and if one man failed to obey an order then the full company was forced to stand to attention out in the yard all through the night. Carl took that punishment stoically, showing no signs of weakness, but the other men did not appreciate his rebellious nature getting them into trouble.

He suffered a few humiliating rapes and beatings, but the fact that he just seemed to shrug them off and get on with his day unsettled the men who were trying to break him. There wasn't a single time when Carl was attacked that he rolled over willingly like so many of the gunsels and victims that the prison's lower social echelons were populated with did. He fought back every single time, with everything that he had. In the beginning, that wasn't enough, but if there was one thing that Carl learned fast, it was brutality. Within a month, he was winning as many of the fights as he was losing, and he had lost all of his appeal to the rapists.

Begrudgingly, his fellow prisoners began to give Carl some respect. While he wouldn't back down to any of them, his response to the guards was considerably more aggressive. He refused to obey a single order that they gave to him, no matter how minor, and when they tried to use force to get their way, he would attack them just as readily as he would any other man. The response from the guards was predictable. They brutalised him to the point of near death, fully expecting the other prisoners to finish the job for them when Carl was in a weakened state. One common punishment for ill behaviour was to fasten men into strait-jackets and tighten them until they lost consciousness: a state Carl was left in almost daily. This actually cemented Carl's position of safety—he suffered alone in silence, and the spark of rebellion within him was just enough for many of the other prisoners to warm themselves by. He was no longer the traitor who had betrayed his country and forced them into constant bouts of group punishment. He was the rebel who stood up to anyone trying to boss him around. The prisoners closed ranks around him, shielding him from the attention of the guards when they could and cheering him on when they couldn't.

Each day, the prisoners of Carl's grade performed a forced march for 4 miles to a rock quarry, where they then worked for 9-hour shifts before marching right back again. Thinking that this was another opportunity to curb Carl's insubordination, the

guards fitted him with the stereotypical ball and chain, which he had to carry with him wherever he went. It was meant to exhaust him to the point that he gave in, but all that it—and every other torment—did was make him stronger.

By the end of the first year in prison, he was as strong as any two of the other men, and at least three times as strong as the average American at the time. When the guards struck him, they were more likely to break their batons than see any actual effect. Just as his first stay in prison had hardened his resolve and his will into something unbreakable, so did Fort Leavenworth make his body into a similar state.

Eventually, even the guards began trying to give him some distance. Throughout all of this, Carl was seeking out the rapists and paederasts that had taken their turns on him when he first arrived in Leavenworth and taking his revenge on them, asserting dominance over them in the only way that he knew how. In prison, many men are made into nothing more than caged animals, but for those like Carl Panzram, it was the first taste of true freedom. His first chance to be the kind of monster that he truly was, with none of the many lies of civilisation confusing matters.

When Carl left Fort Leavenworth in 1910, that experience had sculpted him into the man that he would remain for the rest of his days. In prison, he had seen that his nihilistic worldview, where all men were little more than the sum of their appetites, was entirely accurate. With that knowledge cemented in his mind, he set out to do unto others before they could do unto him. His lifelong campaign of terror could begin in earnest.

Idle Hands Make for the Devil's Work

At 19 years old, Carl was a striking young man with piercing eyes and the kind of physique that only years of hard manual labour could grant: 6 feet tall and weighing 199 pounds of pure muscle. He took to travelling from town to town by train again, but any fear he ever held of being caught soon faded away. None of the bulls wanted to tangle with him anymore, other than the few small groups of hobos that he came across. He honed his skills of violence on them, asserting his control through rape and feeling quite avenged against the homeless men who had taken advantage of him all those years ago.

In Denver, Colorado, he made his first pit-stop of any consequence. Carl would deny his homosexuality throughout his life, coming up with a plethora of excuses for why he preferred to not bed women, but his most common assertion was that women were in some way unclean. He had raped a female tramp while making his journey to Colorado, and by the time that he had arrived in Denver, his aching penis was leaking pus and blood from what he would later describe as a 'first class case of

gonorrhoea'. It left him with no other option than to stop, seek medical treatment, and wait for the cubebs and liquorice mixture that he had to swallow each day to do its work.

By the time the medicine had dried up his infection, he was locked up in the town's jailhouse for stealing a bicycle. While he was in there, his attention was captured by a 50-year-old safecracker who was serving a long sentence for his involvement in a bank robbery. Seeing the opportunity to up his own criminal earnings, Carl cosied up to the man and tried to learn the methods of his craft. The older man immediately benefited from the young monster's extremely physical presence, with any threats against his safety in the holding facility fading away rapidly at the sight of Carl. In return for that, and many other small kindnesses, he began to impart the lessons that he'd learned over the course of his life. Unfortunately for both of them, Carl behaving in a quiet and studious manner resulted in his sentence being served out without the need for any extensions. He was put out onto the street just as he was getting to the good stuff. That same night, Carl broke back into the jail, intent on freeing his teacher, but soon found himself waylaid by a cadre of guards who quickly forced him back into his old cell and sent for the police. A few calls later and he had another month strapped on to his old sentence and all the time that he wanted to finish up his lessons.

Sadly, it was not to be. When the old safebreaker heard about what Carl had done, he assumed that their connection was about something more than just cold practicality. He thought that Carl had feelings for him of a romantic nature, and he wasn't averse to pursuing that relationship. The two of them found an empty cell throughout the day, as was their usual habit, but this time, instead of launching into a detailed explanation of the use of explosives in robberies, the older man planted a kiss on Carl instead. When Carl was unresponsive, the safecracker took it as acquiescence and tried to strip the boy of his clothing. Never in Carl's experience had any of this led to a consensual encounter

so he was immediately ready for violence. He turned on the older man, ripping him out of his jumpsuit and slamming him down to the floor. Carl took him savagely, with no care for the cries and screams. The lessons that he'd learned took over his body and put him into motion. He had to hurt before he could be hurt. He had to dominate or be dominated. Afterwards, the safecracker crawled away to his room and Carl felt quite certain that he'd done the right thing, but the lessons never resumed. The safecracker studiously avoided Carl for the rest of their stay. Carl left jail a month later with no better prospects than he had entered it.

He returned to drifting and church robberies for a time, burning those that he could and simply stripping the rest bare. He made better time now by stealing bicycles everywhere that he went and using those to cross the dirt roads connecting the small towns, where he liked to prey on the local's lack of worldliness. The faster he moved, the less often he got caught and the further he could roam. Eventually, he found himself at the Kansas State Fair, face to face with the first job that he'd ever considered actually taking in his life, at Colonel Dickie's Wild West Show. The Colonel himself, a rather wilted old man by this stage, hired him on after seeing how well he handled himself in a brawl in the stands. They needed strong men like that for the handling of both the animals and their rowdier customers. The prospect of essentially fighting for pay while travelling around the country for free was appealing to Carl, so he took up the offer, only to be discarded a few towns over. The trouble that he encountered was that he was too good at his job. The carnival folk were a tough lot, not prone to taking any insult sitting down, and Carl ended up brawling with almost every man in the circus at least once. The final straw for the Colonel was when one of the show horses bumped into Carl as he was moving them around after a show, and he responded by punching its lights out. He could tolerate a few scuffles among the men. He could even afford to lose a few

of them if it came down to it. But the animals were the show's livelihood, and he wouldn't brook any violence against them.

This slight would not go unanswered. Carl hitched a ride on the back of the show's train when it headed out of town, and when they set up camp at their next stop, he waited until the dead of night before approaching. They were far from the real Wild West here, and no sentries were posted to watch over the camp after sundown. Carl was able to stroll right in, steal a barrel of lantern oil and douse both the cook's tent and the horses' tent before setting both ablaze. The circus awoke to the dreadful sound of dying animals. Far out in the dark, Carl found himself a spot on an overlook and enjoyed every minute of the show, the first real excitement he'd ever drawn from any of their performances. Horses, wreathed in flames, burst out of the burning tent as it disintegrated and charged throughout the camp, wailing and flailing wildly. They set a half dozen of the other tents alight before someone managed to get a bucket chain going, but by then the damage was already done. Not a single one of the animals survived the night, and the circus died with them. All were consumed in the flames of Carl's vengeance. With a smile on his face and a spring in his step, Carl went back down to the tracks and caught the next train to St Louis.

While he was still a free spirit at heart, Carl had enjoyed his little taste of gainful employment—primarily, the authority that it gave him over his fellow man. He may have been able to see through all of the deceptions of normal society, but he wasn't above manipulating the way that others relied on them to his own advantage. He had realised that giving the appearance of playing by the rules made others do the same and gave him the ultimate advantage when their expectations were for things to proceed in the same way indefinitely. That was what brought him to St Louis.

The Illinois Central Railroad company had been paralysed by striking workers who were looking to get a fairer shake in exchange for their often-dangerous work. The whole workforce

had walked out on them, and while not every one of the jobs required a high level of skill, the sheer number of bodies involved was almost overwhelming. There were picket lines everywhere that Carl wandered, every one of them full of self-righteous men standing shoulder to shoulder with one another, bound together by camaraderie and their certainty that right would prevail over power in the end. They were personally offensive to Carl. They stood in direct opposition to everything that he believed about the world. Still, he would likely have just passed them by and said not another word if one of the ICR recruiters hadn't spotted him lumbering down the street, eying them all up. They approached him in a bar that night and offered him a job as a strike-breaker.

There were two types of strike-breaker being employed back in those days. The more official kind, who were known as 'scabs', were willing to work the jobs of men who were on strike for the same paltry wages as the striking workers used to receive. The picket lines were designed to intimidate scabs out of going to work, both by physically blocking their entry and by shaming them for betraying their fellow workers, and with so few scabs available, that tactic was working well in St Louis. That was where the other kind of strikebreakers, the 'blacklegs', came into the equation. That was the job that Carl was hired to do, cash in hand and plausible deniability at the ready. The job of the blacklegs was to charge the picket line and beat the striking workers into submission. Raw violence was the order of the day, and it was there that Carl excelled. While other blacklegs worked in squads against the overwhelming number of strikers, Carl could just wade in with his fists swinging. He was impervious to any feeble defence that the picket lines could muster, ploughing through them like a wild bull and roaring like the same. After his time in prison, he knew that he was a powerful man, but this cemented the realisation of his own physical prowess in his mind. This wasn't brawling, it was outright warfare, and Carl could hold his own against a small army.

It's impossible to say that the strike in St Louis was broken by the pressure of Carl Panzram's brutality, but it is hard to discount it entirely. By the end of a week, there was so much fear of the man that many strikers only had to see his mean stare before they turned tail and headed back to work. Carl was well-compensated, but as soon as he was starting to get into the flow of the violence, it came to an abrupt halt. The strike was broken. He was handed a fat wad of cash and sent on his way without so much as a reference letter. The whole town loathed him by this point, and he couldn't go a single night in the local bars without some young thug trying to prove his mettle by attacking him while he tried to spend that hard-earned cash on liquor. Staying in one place made Carl uncomfortable. He could feel the eyes of the law and the locals on him at all times. Within a week of the strike ending, he was gone, and the stories of his actions began to fade into myth.

While Carl would have rejected any modern notions of a homosexual relationship and seemed personally offended at the idea that he might be interested in any sort of relationship with a man that didn't involve rape, there was a horrific model for male sexuality available to him among the homeless communities that he so frequently travelled through. The 'yegg'.

A yegg was an older male criminal who kept a young man known as a 'punk', or 'Angelina', as an accomplice. The boy was rarely older than his early teens, and the relationship was rarely consensual. Typically, it was the extended abduction of a child who was treated alternately as a tool for break-ins that required the navigation of small spaces and as a sex slave. Angelinas were often traded between different yeggs like property, as part of a financial transaction, because their current yegg had grown bored of them or to help avoid detection by the law.

After leaving St Louis, flush with cash, Carl set about improving on his criminal prospects by acquiring a pair of pistols from a backstreet vendor and an Angelina from one of the yeggs he encountered while hopping trains. The name of Carl's punk

has been lost to history, as Carl never bothered to learn it, but his description of a 'curly-haired, blue-eyed, rosy-cheeked fat-boy' was as complimentary a description as he had ever bestowed on another human being, even if he clearly viewed the boy as an object to be used. The two of them committed burglaries across the country, and while Carl never perfected his safe-cracking, he was able to get through enough of them that they never struggled for cash. Despite this new wealth, Carl never spent a penny that he didn't have to, buying new clothes only when his were falling apart and bothering to dress his punk only long after the point of disrepair. Whether it was his miserly nature or a deliberate attempt at camouflage—to keep the substantial wad of cash in his pack a secret—was never entirely clear to either of them. Regardless, at a glance, nobody would ever know they were anything other than the roaming hobos that they appeared to be.

The more money they took, the faster and further Carl felt compelled to run, and so the less often he liked to hop trains if he didn't need to. He took to carrying a Bible and an account book that he would use as evidence that he was a God-fearing man fallen on hard times rather than a true hobo when the railway bulls came along. Those he could play for sympathy, he did. Those he couldn't, he threw bodily off the moving train. With the extra travelling time came more boredom than Carl knew how to fill. There were only so many times a day he could sodomise the young man he was dragging along with him, so he started propping open the boxcar door and taking pot-shots at farmhouse windows and cattle to work on his aim. If he killed any humans with these antics, there is no record, but he definitely thinned the herds.

Within a month of first acquiring his guns, the duo found themselves in Jacksonville, Texas, where, during an attempted break-in to an old townhouse, the two of them were caught red-handed by the local police and sentenced to work on a road crew. The police confiscated Carl's guns, but they left him his boy. The two of them were set to work repairing Texas' already decaying

roads, camping out under the stars by night and working under the blazing sun all day. The boss of the road-crew took a shine to Carl's Angelina and confiscated him for his own use, taking him off the crew and sequestering him in his own tent. Carl was furious, but with a half dozen armed men between him and what was his, he had no outlet for that fury. After a week, the boss tired of his new toy and tossed him back to the prisoners, expecting at least a little entertainment as they fought over who got to take the next turn on him. None of them dared. Carl had been radiating fury the entire time, and they dreaded the eventual outburst that was sure to come.

Inexplicably, it never did. Carl quietly served out his forty days of time on the gang, and at nightfall on the final day, he approached the crew-boss to request his belongings back. The boss refused to release him. Carl was a workhorse, and if they wanted to get through their appointed tasks, they'd need a man like him on the crew. Needless to say, Carl was not pleased with this response, but once again he took it in uncharacteristic silence. The same night, he made his attempt at an escape, only to be halted by the barrel of a shotgun levelled at his chest by one of the guards canny enough to realise that men like Panzram didn't accept unfairness readily. The next morning, he was given a punishment for his escape attempt even though legally he was a free man. The 'snorting pole' was a typical prison punishment at the time. A 12-foot pole was erected, and a rope was run through a hoop at the top and laced through a pair of handcuffs. They hoisted Carl up until he was balanced on his tip-toes, stripped him naked, and then laid into him with their snake whips. As cruel as this would have been in normal circumstances, it was even worse on the road-crew, as the guards had special 'black snake' whips that were tipped with lead weights, both to make an impression on the large rattlesnakes that populated the area and so that they could be used as a makeshift cosh in case of an attempted escape.

For a solid hour, Carl was whipped bloody by the guards, but while the snorting pole was named for the noises that such treatment drew out of men, they could not get a single sound out of Panzram. When he was lowered back onto his feet, there was no unsteadiness, and when the crew-boss went over to gloat, he saw not a hint of fear on Carl's face. In his own words, Carl found that there was 'blood on his back and murder in his heart' after that treatment, and it seemed that the boss recognised it too, cutting him loose immediately.

Carl walked away from the gang with nothing but the clothes stuck to his back by drying blood, not even bothering to recover his Angelina from where he cowered among the other prisoners.

They might have expected him to die out there with no means to support himself and no money to pay his way, but Carl was made of sterner stuff. For a time, he lived like a ravening animal, robbing chicken coops and then burning them down. Starting grass fires for his own amusement, to help relieve some of the fury within him. Everything that he'd earned had been lost, and all that was left was power and rage: a lethal combination.

More Weight

At some point, Carl found his way to a train yard and made his escape from rural Texas, heading all the way up to Oregon before any further trace of him could be found. He spent a few months working as a seasonal logger in the rich forests of that state, staying well clear of civilisation for a time and letting any heat that had built up in the wake of his latest crime spree die down. It wasn't to last. As soon as he was laid off for the winter, he turned back to crime, working his way down the Pacific Coast leaving a trail of battered men with empty wallets in his wake. Through this time, there was nothing that he would not steal: cash, jewellery, clothing, bicycles and even a yacht that he tried to teach himself to sail down the coast before crashing it into some rocks and swimming to shore.

In San Francisco, he tried to hit up some of his old underworld contacts to move along some of the stolen goods that he'd accrued. Before he went into town, he buried all of his takings in one of the many stashes that he'd made around the country, pocketing only some cash to drink with and a pistol to make any transactions run a little smoother.

There was one bar in particular that was a regular haunt of the San Francisco criminal underbelly at the time—the Louvre,

named after the gallery in Paris because of the nude paintings that adorned its walls and roof. Carl came across a couple of old faces from his previous visits to town, but none of them wanted anything to do with him. Despite that, it wasn't long before he managed to find someone interested in the gold watch he'd brought along with him to show the quality of his goods. He thought that the man was taking him to get some cash for that first transaction when a pair of uniformed officers jumped out and slapped the cuffs on him. After his bragging in the Louvre, the police knew that he had considerably more pilfered goods hidden somewhere, and they were under a lot of pressure from the Oregon cops to find and return them.

There were several closed-chamber meetings with the judge who would be presiding over the case and Carl's defence attorney. In the jailhouse, that attorney delivered the proposed deal to Carl: in exchange for giving up the location of the stolen goods and entering a guilty plea, they would give him a lenient sentence and he could be on his way again soon. Given the choice between that and the seven years he would likely do for grand larceny, the right course was obvious. He signed the confession, wrote out a clear description of the stash, and left for his next round of imprisonment with a smile on his face.

It was only once he had arrived at Oregon State Penitentiary and was being processed that he found out the judge had handed him down the full 7-year sentence regardless. He argued with the warden that the sentence was wrong, that there had been some misunderstanding, but the judge had sent along an accompanying letter, explaining that Carl was a career criminal, known throughout the Northwest, and that his punishment had to reflect not only the crimes for which he had been convicted but all of his past misdemeanours as well.

Carl was tossed into a standard cell when he started ranting, raving and spitting insults, but Oregon State Penitentiary had greatly underestimated his capabilities. In his belligerent rage, Carl was able to bend the rusted bars of his cell out of their

sockets and escape. But, instead of making for an exit, he dove deeper into the prison, jamming rags into every lock so that nobody could move around within the building, beating guards unconscious and, finally, finding the contents of the workshop, which he used to set the whole place alight.

The fire did not spread as far as Carl would have liked, but with the jammed doors, it was practically impossible to fight. The prisoners had to be evacuated into the yard while the civilian firefighters were brought in. The facilities were wrecked and soot-streaked, and it took almost every remaining guard to haul Carl out into the yard. The other prisoners were cheering for him, jeering the guards, losing all respect for their authority. It could not stand. The guards pinned Carl down and broke his ankles with hammers. He would not be standing tall and proud in front of the other prisoners ever again.

His remaining days in the OSP were short. He was left lying on the floor of a solitary confinement cell, starved and in agony as his unset bones began to knit in the wrong position. When he was finally dragged out, it wasn't to provide him with much-needed medical treatment, it was to transfer him to the hardest prison in the whole of the United States: The Salem Correctional Facility.

Carl was barely back on his feet by the time he arrived in Salem, Oregon, but he was not about to show a moment of weakness to the guards or the other prisoners. The moment that he was put into a cell, he filled up a chamber pot and threw it at the first guard to walk by. However grim the treatment had been during his previous prison stays, Carl could not have realised the brutality that he was now going to face in Salem. He was beaten unconscious by a cadre of armed guards and then chained, face first, to the door of his cell. This may have actually helped him, as this time off his feet allowed his ankles to heal without any weight on them, but Carl certainly didn't see it that way. He screamed and hurled vicious insults at anyone who walked by.

He would not show weakness, even though they had him pinned in place. He still would not break.

The Salem Correctional Facility had fallen under the control of a new superintendent named Henry Minto, an ex-police chief who viewed the prison as an investment opportunity. To his mind, the goal of the prison was to generate a profit for the state. The larger the profit, the more that he could skim off the top of that profit to line his own pockets before anyone noticed. His first act in taking control of the prison was to cut the wages that prisoners were paid each day by two-thirds. The money that was meant to be allocated to the families of prisoners was also withheld until they could provide paperwork proving their relationship—something that almost nobody in the illiterate lower echelons of society were capable of. Beyond being his own personal piggy-bank, Minto also ran the prison as his own personal kingdom, demanding absolute personal obedience from all of his staff and the utmost levels of respect from the prisoners in his tender care. If he did not receive the respect that he felt he was due—if he felt slighted in any way—then he had a small army of little tyrants at his disposal who ran each wing of the prison to their own deranged specifications. The man tasked with breaking Carl and getting him on board with the program was known exclusively as 'Vinegar'.

Vinegar was a curious man, as far as prison guards go. A man of very peculiar tastes. To break his prisoners when they acted in an insubordinate manner, he took them into a special room that he set aside for his own use. It was full of little vases full of roses, and their petals would often be knocked loose as Vinegar swung the cat of nine tails that he kept hidden amongst them. For hours he would work the backs of prisoners like Carl with the steel-tipped whip heads, singing hymns to himself as he went. Presumably, he began this habit to drown out the sounds of screams, but when it came to Carl it was entirely unnecessary. The man didn't make a sound.

Throughout all of his many punishments, the guards still could not make Carl submit. Even Vinegar, usually the most talented of Minto's little minions, had no luck with him. Eventually, Minto called Carl into his office and confronted the prisoner on equal terms, thinking that a little bit of respect going both ways might be required to quiet the problem child. Carl spat that respect back in his face. He swore that he was never going to serve those seven years, and nothing that Minto did would keep him in the prison. With the battle lines clearly drawn, Minto smiled and had Carl returned to his cell. The next step of his escalating plan would begin tomorrow.

A common enough torture in Salem was chaining prisoners naked to the wall and blasting them with a fire hose. Carl himself had received the treatment several times, causing both of his eyes to swell shut on one occasion. But that particular water treatment was nothing compared to what Vinegar was instructed to apply to Carl next.

Carl had no idea what to expect when they brought him into the new room, but a bath certainly wasn't at the top of his list of concerns. He happily climbed into the steel bath and let Vinegar cuff his wrist and ankle to a hoop in the middle, only wincing a little as ice water was sloshed in to half fill the bath. He'd had colder washes than this growing up on a farm. If Minto thought that a little chill was going to shake his resolve, he had another thing coming. When Vinegar donned a rubber overcoat and gloves to keep the cool water off him, Carl burst out laughing at how ridiculous he looked. That was when the sponge and the battery wired up to it were uncovered. When it was submerged in the water, all that it did was give Carl an unpleasant prickling sensation all over his body, but as Vinegar began to work his way up, starting at the soles of his feet, the agony began in earnest. The mechanics of this device, known to the guards as the 'Hummingbird', were similar to those employed later in the electric chair. The wet sponge conducted the electricity to a focused point on the body. It felt like searing hot needles were

being rammed into Carl's flesh, but there wasn't a single mark left on his body. He could be tortured like this endlessly without any possibility of dying, or of anyone suspecting that anything untoward was being done to him.

Just as with every other occasion when an institution came down hard on Carl, he came back even harder against the prison—and the superintendent. He set fire to the prison workshop, and in the chaos, he managed to get a hold of one of the axes that the grounds crew used. He went berserk, chasing the guards around all over the prison and helping as many prisoners as he could escape in the confusion. He found that he was too big to squeeze out through the windows that he'd shattered, but if he couldn't get himself out of prison, he was intent on getting every other man free instead. As long as Minto ruled, he would have no peace.

This sort of transgression went way beyond anything that Minto had ever had to deal with before. He needed time to think of a response. Carl was condemned to 'the dungeon', an underground solitary cell where he would spend the next sixty-one days in perpetual darkness. Food was not provided. He had to scrabble about in the dark for cockroaches to eat so that he could survive. By the end of this punishment, nobody in the prison expected him to emerge alive and sane, but there was little change in his demeanour, and he looked as healthy as ever, if a little bit thinner.

From that day forward, the escape attempts were never-ending. Every day, Carl was hatching a new plan and putting it into action, often having a half dozen different schemes in motion at any given moment. He stole lemon extract from the prison stores, distilled it into liquor, and got ten of the fiercest prisoners drunk enough to attack the guards and then snuck a half dozen men out in the chaos that followed. He taught a half dozen others how to smuggle hacksaw blades out of the workshop and use them to cut through the bars of their cell windows. Even the massive sheer wall that surrounded the

prison was just another problem for Carl to apply his incredible practical mind to. Using the handles of buckets and ropes made from shredded blankets, he had men putting together makeshift grappling hooks and stashing them out in the yard ahead of the next group's escape attempt. The purpose and efforts of the whole prison population were turned from obedience and working through their time to extravagant fantasies of escape.

The Hummingbird sang for Carl every day, but afterwards he would limp around boosting smaller men up to windows, teaching others the guard rotations, and threatening violence on every guard that gave him a second look. Among those men was Otto Hooker, a 21-year-old burglar to whom Carl had taken a brief shine. When he escaped, he made for the nearest town and immediately armed himself with a stolen pistol. Superintendent Minto joined in the manhunt with his old service shotgun, as he had a dozen times before, but this time things were different. When he cornered Hooker, the little man replied with a flurry of bullets that tore Minto apart.

This was the very first murder to be attributed to Carl. He was held culpable for the actions of Hooker, and an additional seven years were added to his sentence. Not that he knew that, down in the dungeon. When he emerged from the dungeon and heard the news that Minto was dead, he was ecstatic, but that delight was short-lived. Harry Minto's older brother, John Wilson Minto, had been appointed interim superintendent until a more permanent solution could be reached, and he blamed Carl entirely for the death of his brother. The only reason that he took the job was to seek revenge.

In September of 1917, Carl finally escaped, combining elements from all of the previous escape attempts that he helped to orchestrate into the perfect plan. Using a hacksaw blade, he removed the bars from his cell window. With his new, slimmer physique from hours of walking in circles, he was able to slip through the resultant gap. Using a bucket-handle grappling

hook, he was able to surmount the supposedly unscalable wall and run off. He made a beeline for the nearest town: Tangent.

On arrival in Tangent, he broke into the first house that he could find, securing himself a change of clothes and a loaded .38 pistol. He was headed for the train station to make his escape when one of the local deputies recognised him from the fresh-printed wanted posters in the station and tried to capture him. A firefight ensued, with both men emptying their pistols in the direction of the other, but while the deputy had a whole belt full of ammunition at his disposal, Carl only had the few rounds already in his gun. They were spent all too quickly. He approached the deputy with his hands up, but as soon as the man holstered his gun and reached for the cuffs, Carl went for his service revolver. A wrestling match ensued that only ended when the rest of the sheriff's department showed up in force. Carl kicked out windows as he was dragged away, he sank his teeth into the hands of the policemen, he did literally everything in his power to escape, but they still dragged him back up to Salem, where he was promptly dumped into solitary confinement all over again.

The new Minto set about building a prison within the prison, designed explicitly to contain Carl and the other troublemakers who were following in his footsteps. By the time that construction was complete, starvation in solitary confinement had reduced the ringleaders' numbers to just ten, but those ten were condemned to the fresh hell that Minto had concocted: The Bullpen.

A chalk circle was drawn in the centre of the cavernous room, and every prisoner was required to stay inside that circle for 14 hours a day. If they stepped over that line during those hours, they would be shot. If they took their hands off the shoulders of the man in front of them, they would be shot. If they slowed in their pace as they walked in a circle for those full 14 hours, they would be shot. It was more of a death trap than a

means of confinement, and several prisoners succumbed to it in the months that followed, but not Carl. Never Carl.

When news of the new horrors that John Minto had inflicted on the prisoners during his tenure came to light, the state had no choice but to replace him with a new superintendent. Murphy was the complete opposite of the Minto Brothers, a stalwart reformer who believed that tormenting men in prison did nothing but harden them into even more devoted criminals. He abolished all of the corporal punishment in Salem, tore down The Bullpen, and barred the use of solitary confinement except when it was necessary for a prisoner's protection. The worst punishment that rowdy inmates could expect to face at his hands was being forced to peel potatoes for the kitchens. He improved the food to eliminate the rampant scurvy that plagued the prison, created new jobs for the prisoners to better fill their time, and ensured that they were paid more fairly for that work.

All of the unrest died away. Carl became the sole voice of rebellion in the whole building. Murphy responded by improving his rations and giving him magazines. When a saw blade was found in his cell, Murphy called him up for a polite conversation. Carl laid out his position: he was the worst prisoner in the jail, and no amount of soft treatment was going to make him soft. He was going to fight this warden, just the same as he'd fought every other one. The gamble that Murphy took in response to this statement was stunning. If Carl would promise to return before supper, the gates of the prison would be open to him the next day. He could leave, stretch his legs, enjoy the countryside and do whatever he pleased, so long as he came back before the day was out. Carl made the promise with a contemptuous sneer and every intention of catching the first train he came across.

When the day came, he walked around for a little while, trying to work out if this was some sort of set-up, some excuse to fire on him as an escaping prisoner, but as the midday sun rose above him in the sky, Carl realised that he was actually free. He sat down on a stone and tried to puzzle his situation out. That

evening, he walked back to the gates of the prison and demanded that he be let back in. The only way that he could work out what was happening was to come back and find out more. This kicked off a very brief period of reformation for Carl. He was given a job in the prison, and when he excelled at that, he was invited to join the baseball team that Murphy had just put together. He was bad at the sport, despite his incredible physical condition, and he soon became frustrated at his own failure. Murphy was not willing to give up on Carl, transferring him to the marching band, where he hoped that music might soothe his soul. Once again, Carl did not immediately excel, and he became intensely frustrated as a result. In one of his regular conversations with Murphy, he claimed that he was just too stupid to learn an instrument. The superintendent disagreed entirely, making Carl the band's leader and conductor instead of forcing him to press through more lessons. He toured with the baseball team throughout the summer, visiting other prisons and conducting exhibition matches with only a single guard to accompany them.

On his return to Salem, conditions became even more lax. He would go out drinking with nurses from the local hospital, stroll around smoking late into the evening, and was even offered work placement. There were discussions of parole. He had only four years left in his sentence. But with crushing inevitability, his feral nature reasserted itself.

He rebelled against this kind treatment just as he had the brutality. And on May the 12th, 1918, Carl made his final escape. In the dead of night, he repeated his first plan to the letter, but while before he had relied on stealth to get him out, this time he walked straight to the wall without flinching. The sight of Carl out in the yard by night was familiar to the guards by now, and they didn't give him a second thought, even as he flung his grappling hook over the top. It was only after he had mounted the wall that they finally realised what was happening and opened fire. Every bullet seemed to miss. The glowering look on Carl's face was such that the guards were too frightened to even

aim straight. He took one contemptuous look back at Salem Correctional Facility before dropping down into the forest and vanishing off the map. The guards rushed out after him. Over 200 rounds were fired that night, but not a single one found its mark.

Best Served Cold

After his escape from Salem, Carl changed his name and shaved off his moustache, leaving the Northwest on the first train that he could find. Murphy lost his job almost immediately, and all of the reformations that he had pushed through were stripped away, setting back prison reformation by decades. Carl was in the wind once more. But his experiences in prison had changed him. Despite all of his nihilistic talk about loathing the whole human race, he was wracked with guilt over his escape and the consequences that it had for the one man who had ever treated him decently in his life.

He changed his name from town to town, changed his appearance as regularly as he could manage and changed the patterns of his crimes even more frequently. He was arrested for arson, robbery and even vandalism. Each time he was imprisoned he would escape, mocking the guards and the police that chased him at every turn. The only time that he would serve out a full sentence was if it was less than a month, and even then, it would only be if he didn't have any better plans. Prisons just weren't built with a man like Panzram in mind. Between his physical strength, his ability to manipulate other prisoners into

assisting him and his raw ingenuity, Carl found a way out every time.

After serving three weeks in Rusk, Texas, Carl went on a bender, trying to drink all of the whiskey in town before he moved on. After a few hours of quiet contemplation, he decided that the time for gainful employment had come around again. The US Army wouldn't have him, for fairly obvious reasons, but he suspected that he could make a decent living killing people for the Mexican Army instead. He climbed aboard the first train heading south, but before the train was up to speed, he dismounted again. He spotted a man heading into one of the small towns that he was passing through that had taken his liking.

During this time in America, the Gilded Age, fortunes were being made all over. The promised wealth of the New World was overflowing in every direction, and even here in rural Texas, some men were beginning to show some flash. This particular man had just finished up work in the oilfields to the south and was heading home with a thick envelope of cash for his troubles. Whether it was the money or the man that attracted trouble was unclear, but before he'd made it two steps into town, Carl was on him. There was no need for any cleverness here, no need for any of the guile that he often employed in his crimes. All that Carl needed was the strength in his arms. He seized the lad by the neck and dragged him out of earshot of the rest of the town, then he went through his usual routine.

This boy was not weak by any stretch of the imagination, not after the long months out in the fields, but he was like a baby in Carl's grasp. When he wouldn't part with his money willingly, Carl beat him until he changed his mind. When he didn't want to take off his clothes, Carl beat him until he changed his mind. When he didn't want to be pressed face down into the sand and sodomised so roughly that he bled and screamed, Carl wrapped his hands around the man's throat and squeezed until he fell silent. There were few men who would have gone on fighting

back against Carl after the first beating, and fewer still who would have fought back while he raped them, but that spirit meant nothing in the face of Panzram's raw might. Carl choked the oilman unconscious as he fucked him, and it was only after he was finally finished that he realised that, somewhere in the middle, his victim had died.

It was the rush that Carl had spent his whole life searching for. The one high better than whiskey or sodomy could ever provide. He learned to love the power that his body just barely contained. In the barren wasteland of a world devoid of joy, being able to exert his dominance over other people was the one true delight that he had found, and here in this little stretch of desert, he found that dominance's purest expression. It was the first time that he'd taken a life, but it would not be the last.

Riding high on that murder, Carl reversed his plans, bought himself a train ticket to the big cities of the East Coast, and decided to draw as much pleasure as he could from his life. The efforts of Superintendent Murphy had slowed Carl's descent into darkness and muddled his understanding of the world, but the animalistic joy that he took in choking the life out of that stranger had snapped reality back into clear view: savagery was the only thing that mattered in this world, and there was none more savage than him.

He spent some time in New York, down by the harbour, staring out at the British ships that were docked there. While he'd never studied history in any formal capacity, Carl had learned a fair bit about the clashes that the States had already had with their former owners. Between the Revolutionary War and the War of 1812, there was a persistent feeling that Britain was going to be an enemy that would dog America throughout history. Adding to that historical tension was imperial jealousy towards the boom years that America was currently basking in. Carl had a taste for the act of murder, but just the thought of widespread violence and death was appealing to him, even if he couldn't have direct involvement. He fantasised about setting off

explosives on the British ships, making it seem like a military action and kicking off a new war with America. He even began laying some plans to that effect before he sobered up.

The next time that he went out drinking, his dark thoughts took an entirely different direction. He got chatting with some of the city's sanitation workers and learned the location of the reservoir where the majority of New York drew its drinking water from. He'd never worked with poison before, but he knew of some that would still be effective in that sort of dilution. All that he would need was some capital to make the purchase and he could wipe out half the city's population in one fell swoop. Luckily for the people of New York, it was about then that Carl's drinking money ran out.

He'd been living high on his takings from Texas, but now they were dwindling to pennies. Completely inebriated, he approached a navy ship and demanded that they recruit him. Inexplicably impressed with this attitude, and by the man's physique, the captain of the ship signed him up and gave him an advance on his first week's salary to finish up any business that he still had about town. Carl took that cash directly to the nearest bar and set about working his way through it. Come morning, he showed up at the time he'd been directed to, full of romantic dreams about sailing the sea and waging war. The captain of the ship took one look at him, blind drunk and barely standing, and threw him off the ship. Perfect sobriety wasn't a requirement for joining the navy, but showing up to your duty when you were too inebriated to even make excuses for yourself was beyond the pale.

When he sobered up, that ship had sailed, so he had no recourse for his usual flaming vengeance. With barely a coin in his pocket and a burning desire to lash out at the world once more, Carl finally set his sights on the one man he felt had wronged him the most in his 28 years of life. The man who was by any reasonable measure the most out of his reach: William Howard Taft. The man who had consigned him to Fort

Leavenworth and the most torturous prison experience of his life.

By 1920, Taft had moved on from his role as Minister for War, served as the Governor of the Philippines, and even served as the President of the United States after being hand-picked as Theodore Roosevelt's successor. After his presidency, he considered returning to his law career but realised that all of the federal judges that he'd appointed while president would suffer a conflict of interest every time that he was in their courtroom, so he instead took a position teaching law at Yale. This job and his active political life kept Taft away from his palatial home in New Haven until late hours most nights, and it was this absence that Carl relied on.

He broke into the ex-president's home at 133 Whitney Avenue in the early evening, easily breaking through the feeble locks on one of the windows after the servants had gone home for the night. Taking his time, he began to ransack the bedrooms and a spacious den, accumulating several thousand dollars' worth of jewellery and almost as much in bonds. The prize of his haul was a .45-calibre automatic pistol. From chats during his latest prison stays, Carl had learned enough about the burgeoning science of ballistics to know that any crime that he committed with this weapon would come back to Taft. Every time that he took a life with this gun, William Howard Taft would hear about it and remember how Carl had bested him. He couldn't think of a sweeter revenge.

The house was so huge that Carl had no time to set it alight after ransacking it as he had originally intended. Instead, he leapt from the window with his sack full of treasures as the sun was rising. Without delay, he headed for the railway yard and got out of New Haven before the theft could even be discovered. He had no intention of losing the biggest and sweetest haul of his criminal career.

In Manhattan, Carl was able to fence the bonds and jewellery for significantly less than it was worth. If the sales had

been legitimate, he would likely have made somewhere in the region of $10,000. As it was, he came away with about 3,000 and a box of ammunition.

He had been using the name John O'Leary around New York for quite some time, and it was in that name that he purchased a yacht called Akista at the cost of most of his cash. From Manhattan, he sailed it up the East River, past the Long Island Sound, where he slowed to board the boats that were docked there and strip them of any valuables. Soon, his own ship was laden with luxuries and liquor. He moored at a yacht club in New Haven for a little while, hoping to catch a glimpse of Taft and enjoying the easy access to the bootleg liquor that was flowing through the town, but after only a few sunny days lounging around, he found himself restless yet again.

Raising sail, he headed up towards the Bronx, anchoring off the coast of City Island. At that time, City Island was a secluded maritime community, full of fishermen and sailmakers who kept to themselves.

The surly attitude of Captain O'Leary was noted, but hardly uncommon among travelling sailors, and given that he only came ashore to take on supplies, it was likely that he would have escaped notice entirely if he hadn't been so efficient in his latest murderous scheme.

Travelling down to Manhattan, he would trawl the speakeasies and streets for sailors who were looking for work to tide them over until their next duty began. The cunning part of Carl's plan for them involved the location of his ship. Because he had berthed so far away, the sailors were forced to go and collect all of their worldly possessions from whatever temporary accommodation they were staying in or risk them going missing while they sailed with him.

For most of those men, that first day working as crew for 'Captain O'Leary' was the easiest day of work that they'd ever done in their lives. He was clearly capable of handling the running of the ship himself but preferred to have someone along

to drink and chat with as the day rolled on. Come nightfall, he would drop anchor out by Execution Rock Lighthouse in the sound and prepare a hearty meal for the two of them, a meal that would usually include extra helpings of wine and liquor with every mouthful. Completely inebriated and unable to keep up with the hardy drinking constitution of Panzram, they would barely be aware of what was happening as he stripped them, flipped them and then raped them for dessert. Some of the men still had the wherewithal to scream, but out there in the ocean, there was nobody to hear it.

Once Carl was finished taking his pleasure in the inebriated sailors and had squared away their belongings below deck, the next sound to ring out from the Akista was the sharp snap of a .45-calibre pistol. Taft's pistol. Next, Carl tied a rock to the body's foot, tossed the naked corpse overboard, and set a course back to City Island so that he could start the whole process over again. For the three hottest weeks of the summer, he went back and forth from Manhattan to Execution Rock, robbing, raping and killing. Over and over. In the end, there were ten dead sailors sunk by Execution Rock.

The people of City Island had finally taken note of O'Leary's perpetually changing crew and the fact that his ship was overflowing with property that he had no good explanation for accumulating. Nobody approached him, but he gradually became aware of the eyes on him every time he came ashore and decided that the time had come to move on.

Even though he had to abandon his berth, he wasn't yet ready to abandon his latest murderous scheme. This time, when he swung by Manhattan, he collected two new sailors to man his ship. They weren't as pretty as his previous acquisitions, but what they lacked in charm they made up for in willingness to break the law at Carl's command. While he'd read stories of cowboys when he was growing up, Carl had consumed just as many tales of pirates, and that was another ideal of a romantic outlaw that he was quite attached to. As they sailed down the

New Jersey coast, Carl and his crew robbed every yacht that they crossed paths with at gunpoint, accumulating a hoard of loot that any Buccaneer in Carl's stories would have been proud of. He was free and easy with the loot and the liquor, promising the men far larger shares than could reasonably be expected for their fairly minor contributions to the crimes.

To begin with, they may have suspected that he was a fool, but after watching his cold-blooded behaviour during their raids, the sailors gradually came to realise that Carl was smarter, and more vicious, than he looked. Their ultimate destination was Long Beach Island, just a little north of Atlantic City. On arrival there, Carl intended to rape and murder his two co-conspirators as he had all of their predecessors, tossing their bodies overboard to be found by whoever happened upon them, before continuing down the East Coast away from suspicion.

By the time the lights of Atlantic City appeared over the horizon, it was August of 1920 and the summer heat was beginning to give way to more turbulent weather as the pressure dropped. Carl was a capable enough sailor for any man who was self-taught, but he did not have the skills to navigate through the storms that they were now facing. A massive gale swept in from the Atlantic and battered the Akista into some hidden rocks. The hull gave way under the pressure. All of the loot that filled the lower decks was washed away in an instant, and between one moment and the next Carl went from being on top of the world to being dragged down into the cold dark waters as his ship— his pride and joy—sank to the bottom of the sea.

It's hardly surprising that Carl survived this ordeal. He was a strong man, in his prime and a capable swimmer. What is surprising is that the two sailors he brought on board survived, too, making landfall on the beaches of the Brigantine Inlet and running off into the Jersey farmland before Carl could catch up to them. Whether they were merely lucky or they suspected the fate that lay in store for them and were taking active steps to avoid it is not clear. But the fact remains that those two men are

the only victims that Carl Panzram marked for death who survived, and it took an act of God to deliver them from his clutches.

Carl was bitter about losing his boat and all of the wealth that he'd filled it up with, but not half as angry as he was about losing Taft's pistol to the murky depths. Money was a temporary thing in his worldview, something that passed through your hands as swiftly as it came to you, but revenge, revenge was forever once you had it. His roaring rampage of revenge against Taft, in particular, was meant to go on for years, with more and more murders being pinned to the ex-President's pistol every passing day. It was not meant to be cut short by a gust of wind and a splash of rain. Carl baulked at the unfairness of it all, but he had no recourse against nature.

A Normal Man

With nowhere to turn his rage, Carl returned to his old routines of brutality, riding the rails and forcing himself on any men that he could lay his hands on. It wasn't enough anymore. The high that he used to get from bullying and molesting men had faded in comparison to the sharp jolt of ecstatic pleasure that he drew from killing. Even the sweetest pleasures that he'd known before were fading away in the face of murder.

Running wild as he was, it is hardly surprising that he soon attracted the attention of the law once more. Thinking to repeat the wild success of his robbery of Taft's mansion, where he'd acquired enough cash to purchase a yacht, he returned to the wealthy university town of New Haven in the early days of 1921, taking his time to case a few of the mini-mansions that filled the town before finally settling on one as his target. Almost immediately, he ran into problems. The family that lived in the house were both present and awake when he broke in, and while they were easily cowed by Carl waving a newly acquired pistol around, the staff were not so foolish. A quick phone call later and Carl was arrested by the local police and carted off. Charged with possession of an unlicensed firearm and burglary, Carl should have been looking at many years in jail, but because he gave yet

another false name to the police in Bridgeport, this was treated as his first offence, and he received a sentence of only six months.

Once again, Carl was confined in a prison run by people with no idea of the trouble that they'd just brought down on themselves. Out in the real world, when Carl brutalised a man, raped him or robbed him, he could expect to see consequences for his actions, but the law did not care when these things happened to a prisoner. In fact, there was tacit approval for any torture that Carl happened to inflict. It was almost like a holiday for Panzram, an opportunity to regain his strength and composure after the shipwreck. The confinement was good for him—it helped him to find balance again instead of spiralling into ever more self-destructive behaviour. By the time that he emerged from the prison in autumn, he was behaving like the cold, calculating killer that he'd become instead of some ravening beast, and he judged that it was once again time for him to seek out some gainful employment that might suit his talents.

The ocean still called to Carl, but he now realised the dangers that his ignorance of proper seafaring had dragged him into. It was pure luck that he'd survived the sinking of the Akista. For a man as determined to control everything as Carl, that was intolerable, so he set out to improve himself the only way that he knew how, by joining the Flying Squadron of the Seamen's Union.

Normally, they would have had no interest in bringing on a man with so little experience at sea, but the situation was complicated by the fact that the union was currently in dispute with their employers and coming into almost daily conflict with scabs and strike-breakers. Carl may not have been much of a sailor yet, but if there was one thing that he could do, it was fight. Over the course of a month, he refined his skills as a sailor under the tutelage of the older men and repaid that education with carnage many times over. When Carl strode out on the picket line, the professional thugs that the shipping lines had brought in to bully the union boys mysteriously faded away. When scabs

tried to push through the picket line, they ended up with broken bones, tossed in the harbour or much worse if Carl was able to drag them off into a dockside alleyway. Carl was a tremendous asset to the union, but he was also incapable of backing down.

When the blacklegs escalated from fisticuffs to carrying guns, Carl mirrored them, and when they came stomping up bristling with armaments, Carl didn't give them the chance to use them. He opened fire on the strike-breakers before they could even approach the picket line. A running gunfight started up between the two factions, with the police arriving somewhere in the midst of it. They immediately sided with the company men, seeing this as an opportunity to end the nuisance of the strikers on their docks, and while the rest of the union were ready to stand down in the face of the law, Carl was not. He fired on the police just as readily as he'd attacked the blacklegs. The gunfight became even more pitched, with the union now realising that they were fighting for their own survival rather than just victory in the conflict, but eventually Carl and the few other shooters on the picket line ran out of ammunition, and the charging police were able to bear them down by weight of numbers.

Nobody could say for certain who'd started the gunfight when it was all over. The union lawyers made sure to coach every man who'd been taken into custody to repeat that protestation of ignorance. For the police's part, they were facing scrutiny for the way that they'd leapt into the fray, with accusations of corruption and bribery by big business dogging them. All of the union men were released on bail pending trial for their involvement, bail that was paid by the union itself.

Carl had made a target of himself by playing such a central role in the union conflicts, and it didn't take long before news of his exploits elsewhere began filtering through to the investigating officers. While they may have been able to press charges on a few of the union men for their involvement in the clash with the police, the investigation soon centred on Carl Panzram, along with his many aliases, prison breaks and

outstanding warrants. Once they had only a fraction of their full case built against Carl, the police swept the docks looking for him, ready to return him to prison where he rightly belonged and to heap enough years on his many outstanding sentences that he would never see the light of day again. But there was no sign of him. They sent out his description to every police department in the country, but nobody had seen hide nor hair of him since he was released on bail. Even shaking up the union boys who might have been giving him shelter provided the police with no leads. Finally, in desperation, they started searching through the records of all the ships heading out of the USA, for any of the aliases that Carl had used through the years, but it was hopeless. It was like the man had just vanished.

Light on funds but heavy with need, Carl had done exactly the same thing as always to get out of town fast—he'd stowed away. The ship that he slunk onto was bound for somewhere far beyond the reach of the American law: Portuguese Angola, on the west coast of Africa. After a few days of lurking in the ship's hold, trying to stay out of sight, Carl became bored and revealed himself to the crew. The captain was initially furious that a man had stowed away on his ship, but it didn't take long before Carl put the skills that he'd learned on the Akista and with the Flying Squadron into action, earning the crew's grudging respect.

It was a long voyage with few stops, but by the time they arrived at their first one in Portugal to restock their supplies, there was no question of putting Carl off. He was doing the work of two men for nothing in exchange for his passage. By the time that the coast of Africa came into sight, the captain was practically begging Carl to stay on as a permanent part of the crew. After all, the sea was a good place for a man with a bad reputation or a dark past to get lost and forgotten about. Carl politely declined. The level of discipline and hard work required on a ship reminded him entirely too much of life in prison. He wanted to roam the world and do whatever wickedness he wished, answerable to nobody. He shook the captain's hand and

stepped off onto the docks, freed from the constant threat of arrest for the first time in his adult life.

Angola was the perfect place for Carl, a place where human life was worth nothing, at least to the white colonisers who treated the local population as less than animals. Protected by the colour of his skin, Carl roamed around Angola for several weeks without fear of any comeuppance for his actions. The few dollars that he'd left America with were worth infinitely more here than back home, and he was able to live in comfort for pennies a day. Still, there were dark and gruesome luxuries that could be openly purchased here that were just slightly out of his price range, and Carl longed for them. With the local population so destitute and the white settlers so well-guarded in case of an uprising, stealing to fund his lifestyle was not an option, so Carl had to resort to working once again.

The Sinclair Oil Company was doing an expeditionary exploration of the oil reserves of Angola; one of the few American companies to have gained a foothold in the country. America's oil demands were increasing exponentially through the years, and enough fortunes had been made in the fields of Texas that everyone was now hungry for a slice of that pie. The company had no need for recruitment back in the States, having their pick of the best men. But here on the ground in Angola, they were struggling to keep their workforce full. No small part of this was due to the rather taxing moral requirements of the job— work on the Angola fields was lethally dangerous, even by the standards of the day, so dangerous that the company wasn't really willing to allow any white man to risk it.

The oilmen had become little more than glorified slavedrivers for the local workers. Carl took to the job with a gusto that even his employers found a little disconcerting. He delighted in treating the local men like dirt, and he pushed his little team harder than any of the other oilmen would even have considered. What he lacked in applicable knowledge about the mechanics of the job, he more than made up for in enthusiastic cruelty. The

amount that his rig was producing surpassed all expectations and Carl was rewarded handsomely for his efforts.

In Africa, he felt like he was able to start over. He had a whole new life here, a life that wasn't so far out of the ordinary that it would raise the eyebrows of any of his peers. His sadism was rewarded monetarily as well as with the burning satisfaction it usually brought him. He was convinced that he could be a normal man in Angola, but to achieve that normalcy, he felt that he was going to have to move past one of his greatest revulsions. In the coastal town of Luanda, near to the drilling site, Carl approached a local family with two daughters, and making use of one of the company's translators he asked them to name their price for the older of the pair, an 8-year-old. After some haggling, a price of $6 was agreed. Carl insisted that their deal was contingent on the little girl being a virgin. He had no use for her if she was not a virgin. The father promised that she was untouched by man, but Carl was still suspicious.

The company had provided Carl with a spacious cabin on the periphery of their camp, and that was where he took that little girl back to that night. He intended to have sex with her, to prove that he could be a real man. He could not understand why his body would not respond to the demands of his mind when normally he had no trouble at all performing sexually at the drop of a hat.

Unable to confront the fact that he was not attracted to women or girls, he placed the blame on fear of infection. He would have to prove to himself that this tiny child was a real virgin before he had sex with her. The thorough examination that he conducted lasted through the night, and the child's strangled screams echoed out through the camp, stirring all of the other Sinclair men and making them wonder what fresh hell Angola had decided to deliver onto their doorstep. Come morning, Carl emerged with the 8-year-old dangling in his grasp, glowering at any man who dared to look his way. He marched back into Luanda and demanded that the parents exchange this daughter

for their other. She had not met his standards, and he suspected that she had already been engaging in sex. With no other option, the parents handed over their 6-year-old and took their ruined older daughter inside to wait for a local doctor to come stitch her up.

Carl was spotted with the little girl in tow when he arrived back at the camp, but none of his co-workers dared to confront him. His comings and goings had been reported to his supervisor, but the company line was that as long as he wasn't raping and murdering anyone white, they didn't give a damn. The camp settled in for another sleepless night, every ear cocked for the start of the screaming, but it never came.

In his cabin, with that terrified little girl stripped naked on his bed, Carl was finally forced to confront the truth about himself. As much as he might like to pretend that he was just like all of the other men working for Sinclair, he was fundamentally different. It was all a charade, and his lack of interest in the opposite sex marked him as a monster in his own mind. He was incapable of the 'normal' pleasures that men took in women and only grew aroused at the thought of violence, arson and sodomy. He carefully dressed the little girl and took her home to her parents. When the banging on their door came in the middle of the night, they braced themselves for Carl's next dreadful demands, but instead, they found their daughter thrust into their arms and the dreadful giant of a man storming back off into the dark without even a demand for a refund. To Carl, it had been worth the investment to learn the truth about himself, that even when a girl was virgin and helpless to stop him, he still had no desire for her.

Over the following days, Carl turned to whiskey for comfort, lounging around the open-air mess hall that had been set up for the white employees and indulging in his first true love until the early hours of each morning. The regular staff cleared off at midnight, but the teenage son of one of the local oil workers had acquired a part-time gig as a waiter, and Carl was generous

enough with the tips that it made it worthwhile for him to linger long after everyone else had gone to their beds, fetching out the whiskey and refilling Carl's glass on demand. Carl was obnoxious to the boy, treating him like a savage with little more intelligence than a beast of burden, but in this he wasn't much different from any of the other white men the boy had met, so he didn't take it personally. For all that Carl spoke down to him, he was still considerably more civil than a lot of the men around camp—men who could not slip in and out of the savagery required of them so easily and had to keep their emotional walls up at all times.

As they spent more time together, the formality of their respective stations faded away, and the boy ended up sitting and drinking right along with Carl on more than one occasion. The boy started to feel like he was being treated as an equal, that Carl's 'educational speeches' were actually intended to help improve his English and his ability to join in conversations with the other white men. When Carl started talking about the ancient Greeks, the boy thought it was just another history lesson, another set of references that might help him navigate the idiom-laden conversations of the English speakers. That was not the lesson that Carl intended to impart that night. He had a more physical education in mind.

The boy did not take well to his education in sodomy, and Carl had no choice but to force him into taking that first lesson against his will. It was no more or less brutal than any of the other rapes that Carl had perpetrated back in America, but it was the first to happen in a country where there was no instilled sense of shame about homosexuality. The boy did not blame himself for his assault, nor did he think that it made him into less of a man, given that he had no issue with reporting Carl's horrific actions to his supervisor. The supervisor was stuck in an awkward position. Ultimately, he didn't give a damn about some serving boy or his father on the crew. The one thing that the Sinclair Oil Company was not lacking was black bodies to throw into the grinder. But, the perversion that underlay Carl's actions

could cause trouble. If the boy was willing to speak out to someone in a position of authority, then there was no question that the story would spread in no time at all. The Americans would start coming and complaining about it next. Then, there would be the awkward rearranging of schedules to avoid putting Carl anywhere near the men who hated him for his deviance. Normally it would have been a lot of work to protect a deviant from his well-deserved beating but in Carl's case, he would have to do it for the protection of the rest of the workforce. Whatever else Carl may have been, there was no doubting that he was dangerous. Carl's supervisor did not need that kind of trouble in his life. Firing Carl was the path that led to the least trouble in the long run. It was almost a kindness to get him out of camp before the story started to spread and ruined his reputation permanently.

Needless to say, Carl did not see things that way. After his boss called him into the office ahead of his first shift of the day to lay down the law, he sat quietly through the denigration. When everything was said, he rose up out of his seat and slugged the man in the face. His supervisor was not a weak man. He'd come up through the oil industry the hard way back in the States, but he was no match for the raw ferocity of Carl Panzram in a rage. Carl beat him and beat him until the man didn't have the strength to pick himself up off the floor. Then Carl picked up his chair and beat him some more. By the time Carl had packed his bags and stormed out of camp, his former employer had slipped into a coma.

At first, he went back to Luanda to wait out the immediate aftermath of his latest crime in relative comfort. There were no police in Angola or at least no police who would dare to arrest an American. This meant that the Sinclair company was a law unto itself, which worked out perfectly most of the time but fell apart when a man like Carl came into the picture. For obvious reasons, Carl did not get his last pay stipend, and he'd already drunk the vast majority of the last one. He spent a single night in one of

Luanda's bars and brought himself close to bankruptcy. With no real prospects left in Angola, he turned tail and fled to the American consulate to demand a berth on a ship heading home.

The consul refused point blank. Stories about Carl's crimes had already been delivered from the Sinclair company, but they had been preceded with warnings about a dangerous man who'd escaped the reach of the law back in America. All of Carl's crimes were coming back to haunt him now that the police in New England had begun to piece his story together, and they'd been delivered in a neat bundle to the consulate in Angola after suspicions about him jumping ship had taken root. If it hadn't been for the armed guards posted just outside the door, the consul probably would have chosen his words more carefully, but as it was, he was free to be entirely honest. He told Carl that he was a monster, that America did not want him back, and that the best thing for everyone would be for him to walk off into the deepest darkest forest that he could find and never come back, because the only thing that he had waiting for him in America was jail-time, or the noose, if there were any justice in the world.

Heart of Darkness

Carl was cast back out into the streets with no more recourse than any of the locals around him. Banished from his homeland for his brutality and his proclivities, stranded on the far side of the world with access to nothing familiar to lean on. He retreated back to Luanda, living as free of costs and ties as he had when he was riding the railroads back home. He soon set up camp in a park near to the oilfields, where he intended to prey on any of the wealthy Americans that he spotted coming out to trade with the locals. His dwindling coffers would be refilled, and he would get the satisfaction of some revenge against the Sinclair company for crossing him. If he had the chance to maim or molest one of the men he'd once called colleagues, the ones who'd looked down their noses at him all those long months, then so much the better.

The men about camp knew that Carl was out there somewhere, and while there was no curfew or policy issued, they tended to travel in groups when they had to make supply runs anyway. They were already afraid of an uprising by the locals. Carl was just another danger tagged on to the long list of them that the colonising oilmen faced.

So, the days stretched on with Carl getting no satisfaction, baking in the sunlight and shivering through the night. He was

lying out there on the grass when one of the local boys found him one morning. The boy could've been no more than twelve, and he spoke barely a word of English, but he'd clearly been sent on some errand about the Sinclair company and approached Carl in confusion when he couldn't find their encampment. For his part, Carl was more than happy to play along and act as a guide, leading the child off along a forest path and hiking on for an hour in companionable silence until they came upon a disused quarry that the Sinclair company had exploited for building materials for their rigs in the early days.

The boy was confused, and that confusion rapidly turned to abject terror as Carl ripped away his clothes and threw him to the ground. As Carl forced his way inside the little boy, the child's screams echoed out through the quarry, but there was nobody around to hear him. Realising that there was no hope of rescue and in agonising pain, the boy tried to fight Carl off. Carl was not so easily dissuaded, especially not when he was already in the midst of his favourite act. He took hold of the boy's head in both hands and pounded it against the rock in time to his thrusts, hammering that fragile skull against the solid stone beneath him. Blood began to pour from the boy's ears, but still he flailed and struggled, so with one last monstrous effort Carl slammed him down again, shattering the child's skull and achieving his climax. After he withdrew and fumbled himself back into his pants, Carl looked down on the little dead boy with fierce joy. Gelatinous lumps of the boy's brain were oozing out of his ears amidst the wash of blood. Spreading out over the stone.

For all of his protestations that he was a cold and hardened monster who was immune to the mores of his time, Carl seemed to suffer greatly every time he was criticised in any way. Acting out with violence was always his immediate solution to reassert his control, but when that wasn't an option, as it hadn't been when the consul tore into him, it deeply affected him each time. Every time that he was faced with an authority figure whom he couldn't immediately blame for all his ills or spit in the face of,

he seemed surprisingly cowed. His nihilistic worldview seemed to crumble every time he was confronted with comfort, kindness or normalcy. After being faced with either of these emotional conflicts, it took a dramatic event to remind him of who he claimed to be. Killing that little boy was the trigger that brought the 'real' monstrous and vengeful Carl back to life.

In the Sinclair camp, the name of Carl Panzram had been almost forgotten. His supervisor remained under medical care, but his coma had come to an end, and the men had slipped mostly into their old routines, competing with one another for the top production spot now that there wasn't a clear unbeatable leader in the race. After a long day's work, the locals had returned home to Luanda and the white workers had settled into their cabins for the night, bone-tired but satisfied. None of them knew what was happening when the alarm went off, or when the camp guards came banging on their doors, screaming for help. The whole camp was roused and staggered bleary-eyed out into the pitch darkness of the Angolan night, illuminated only by the inferno on the horizon. One of the rigs was alight.

It was no wonder that the whole camp had been stirred. If the oil caught fire, they could kiss their livelihood, and most likely their lives, goodbye. Even as they ran with buckets of water to try and quench the blaze, the question was already being barked back and forth. How could this have happened? Nobody was stupid enough to smoke by the rigs, and nobody would be out on the field in the dead of night. It made no sense. Working together in a bucket chain, the whole camp took three hours to fight the blaze, but even when it died down it was mostly because there was no more wood to fuel the flames. The whole rig was nothing but ash by the time it was over. A tenth of their production, gone in one night.

With the dawn came the question again, repeated over and over around the camp. If there was some problem with the pumps that could cause a fire like that, then it put them all in danger. If there was some fool strolling around the field at night

smoking, then he needed to be put out. Fingers were being pointed in every direction except for the right one.

It had been a long time since Carl committed an act of vengeful arson, but much like riding a bike, you never forget how once you've learned. With that being said, Carl had picked up a few new tricks through the years since he first set the Painting Room aflame. For instance, he'd learned to dispose of the tools of the trade in the blaze that he'd started, and learned that after a fire was put out, everyone started looking for the man to blame, and it would be in his best interests not to be around when that happened.

Fleeing Luanda with only his ever-dwindling savings, Carl travelled down the coast to the fishing village of Lobito Bay. Lobito Bay made Luanda look cosmopolitan, fulfilling almost every racist stereotype that had been perpetuated about the 'savage' Africans, right down to straw-roofed huts. Here, Carl found that the little money he had stretched even further than it had back up north, and he was able to idle for several weeks in the most luxurious accommodation in town drinking the locally distilled rum. But eventually, even Carl's thirst for liquor was quenched, and he became restless once more. There was very little to do in Lobito Bay, but some of the locals had discovered a cottage industry canoeing European hunters inland and up-river to hunt the river-crocodiles, which were rumoured to grow as big as the boats themselves. Usually, a crew of six men accompanied a trio of hunters on a three-day round trip, but Carl hired those six locals and their boat for himself with the last of his cash.

All through the day, the men pulled against the current, pointing out the smaller crocodiles that came down towards the river mouth and promising him far bigger game up ahead. When night fell, they made sure to pull their boat inland as far as they could, well aware that the crocodiles became more active at night, and they were now deep enough into the forest that they were likely to encounter some real monsters. Heading even deeper into the forest, they found an old campsite and set

themselves up with a fire stacked high enough to last them through the night. All nine of them carried their rifles with them at all times. They were a good distance in from the river, but the crocodiles weren't the only predators to stalk that forest at night, and they needed protection. If only they'd realised that the most dangerous predator in the jungle walked among them.

After a mediocre meal of preserved meat, they settled down for the night, with a man standing guard in shifts while the others slept, but the same restlessness that had driven Carl out of Lobito Bay was still at work in him. He could not sleep; he could barely lie still. The anticipation of the kill was overwhelming. The guard tried to stop him when he moved to leave camp, and his English was not good enough to understand Carl's explanations until he started miming. Once he understood that Carl was heading off to use the bathroom, he begrudgingly accompanied him into the treeline to watch over him while he did his business. They did not return for quite some time, so long that the next shift of watchmen had already roused by the time a gunshot rang out in the distance.

That sound was so familiar that it didn't even rouse the rest of the hunters from their sleep. Discharging a weapon to startle off a predator was so common that if they stirred each time it happened they'd never get any sleep at all. They slept on, safe in the knowledge that they were being watched over by one of their friends. When Carl came back to camp alone, he had to rely on miming once more to lure the next guard away. He raped that second man just as he had the first, thrown over a toppled tree trunk and yelling for help from friends too far away to hear. His screaming just grew louder when he spotted the corpse of the last guard lying a few feet away with a bullet hole in the back of his head. A portent of his own future.

One by one, Carl lured his hired crew away, raped them, murdered them and robbed them of the very money he'd put into their pockets during the daylight hours. Six men, killed one after the other, raped one after the other with barely a half hour

between them. When Carl came for the last man, he was still dreaming, still blissfully unaware that death loomed over his sleeping form with a grin. Carl raped and murdered that man right there in camp, then began the arduous process of cleaning up after himself.

Down by the river, he caught sight of the monstrous crocodiles that he had been promised, but while he kept his weapon ready it seemed that the creatures sensed some primordial kinship with the man and didn't trouble him at all. If anything, it seemed that the crocodiles were grateful to Carl for the substantial meal that he delivered to them in six bite-sized pieces.

With the last of his hunting guides consumed, the ecstasy that had been carrying Carl along since he rose from his bedroll the night before began to fade under a wave of exhaustion. He dragged the boat back to the water and rode the currents down to Lobito Bay, looking forward to resuming his life of leisure and getting a good day's napping in the sun to recuperate.

His stay in Lobito Bay was about to come to an abrupt end. There were many questions waiting for him there, and the locals did not buy his story that the guides had been attacked by crocodiles, not for even a moment. Everyone had seen him hiring his guides, everyone had seen them heading upriver together and everyone had seen Carl come gliding back down the river without a scratch on him when every one of their trained and hardened hunters had vanished into the great green expanse.

Fury began to build, and the entirely appropriate amount of blame was attached to Carl. But even with everyone knowing what he'd done, they couldn't bring themselves to take action. As evil as Carl was, and as terrible as the murders were, they were nothing compared to the misery that would be brought down on Lobito Bay if the Portuguese found out that a white man had been killed there. The whole village would've been razed to the ground. Once again, luck saved Carl from facing the consequences of his actions and he was able to slink away.

He did not resurface in Angola for a few weeks, living rough and roaming around the farmland further up the Golden Coast, preying on locals. When he did finally reappear in the public eye, it was only very briefly. All of the American ships at the docks had been warned about him, told that he was known to stow away, and informed of the sickening nature of his crimes against his fellow man. They were ready for him when he came strolling along the waterfront, and they were ready for him when he tried to climb on board in the dark of the night. Thwarted and dunked into the water one time too many, Carl changed his tactics, ignoring the ships that were heading back home and trying to find one that might take him anywhere. He was in luck. There were far more Portuguese ships in port than American, and it hadn't occurred to the consul, nor the Sinclair company, that he might be willing to travel back home in stages.

Slipping aboard a ship to Portugal, he repeated the same pattern of behaviour that had landed him safely in Angola, revealing himself to the crew after only a few days at sea and fumbling his way through the Portuguese conversation with the captain just well enough that he was able to make his case and work off his passage.

He arrived in Lisbon, Portugal, with a spring in his step. Every new place that he visited he treated as a fresh start, and while Portugal didn't bear much resemblance to America, there was enough familiarity that Carl was able to find some liquor and some people worth robbing before too long. The old world was a smaller place than Carl was used to. Where in America he could commit a crime and hop a train outside of the relevant jurisdiction, in Portugal, the police were on him like a rash. All of the easy living he'd experienced in Angola, where he basically worked for the local lawmakers, had left him out of practice. So within a week of arrival in Portugal, Carl showed up at the American consulate begging to be sent home.

Even half a world away from where he was last spotted, the stories of his crimes had preceded him. The consul in Portugal

wasn't so brusque as his Angolan counterpart, but he still had no intention of offering any aid to Carl. As long as he was out of America, he was somebody else's problem, and there was a vague hope that he'd stray so far off the beaten track that he might end up dead and buried in a shallow grave out in some backwater, ridding the world of this menace forever. Not to be dissuaded, Carl did his best to stow-away on an American ship but soon discovered that, once again, they had been forewarned about his presence and battened down the hatches, both figuratively and literally. So, he snuck aboard a different nation's ship once again, hoping to continue his journey home in little hops across the Atlantic. He boarded a British naval ship bound for Glasgow, Scotland, fully intending on repeating the same pattern that had carried him safely around the world so far. Unfortunately for Carl, the British did not share the lackadaisical attitude of the merchant sailors he'd encountered so far when it came to stowaways. He was discovered before he had the opportunity to reveal himself, flogged against the main-mast, and confined in the brig before he even had the opportunity to speak. He spent the remainder of the journey chained up and eating rats down in the creaking darkness.

On arrival in Britain, his punishment wasn't over. Official records of his confinement to jail in Glasgow had him marked down for a year-long sentence, but using the skills he'd acquired during his formative years, Carl was able to slip out hidden among the laundry. This time, he approached the docks with an entirely different approach, offering up a false name to any captain bound for the Americas but recounting his true experience as a sailor, piloting his own yacht, training with the Seamen's Union, and his two stints on merchant ships heading in and out of Africa. There were men with more experience than Carl on those docks looking for work, but there were none that looked stronger or who were willing to work for nothing but board and passage. He left Britain with the next tide and brought

his long odyssey to the East of America to an end before the year was out.

The Boys of Summer

In 1922, Carl arrived back in New York just as it started to heat up for another scorching summer. After his experiences in Portugal, he had no intention of lingering in a city through another season of sweltering misery. He made a brief stop to acquire the filed papers of the Akista from the port authority, without mentioning that she currently resided somewhere on the bottom of the ocean. He then started exploring the various docks around the city, intent on stealing a yacht that was similar enough to the Akista that he could refit and repaint it without too much trouble so it would look like it was actually his boat. He hadn't given up his dream of travelling the ocean freely with nobody to hold him down, and he now had the skills to sail without fear of nature's wrath.

After exhausting the shipyards and docks of New York with no luck, he drifted further north. The seaport of Providence, Rhode Island, seemed like the ideal place to find a ship like the Akista, and Carl lingered on those docks for almost a week before abandoning the search and moving on up the Boston Road.

During his long stints at sea, Carl had become quite introspective. He'd realised that his career as a burglar had never shown much promise in comparison to his talents for other

things. The slaughter by Lobito Bay had underlined Carl's suspicion that murder on a grand scale was his calling in life. It'd been so easy for him to blot out six grown, armed and hardened men that it had completely changed his perspective on life. Killing had been his passion since the first time he choked the life out of a man, but it had never occurred to him that it could be a lucrative career until he arrived back in the states to see prohibition in full swing and mobsters swaggering through the streets like they were movie stars.

He acquired a high calibre pistol of the same make that he had used in his African murders and carried it with him everywhere that he went, just dying to find another opportunity to use it. In Hartford, Connecticut, he found the final piece of the puzzle to begin his career as a hitman: the Maxim Silent Firearms Company. He waited silently in their offices while the work was being carried out on his beloved pistol, ignoring any attempts at pleasantries from the secretaries or sales staff. He paid his tab and left town immediately, heading for the nearest patch of rural land to try out his new silencer. It didn't work. Or rather, it worked, but not nearly well enough for Carl's liking. A silencer can drop the volume of a weapon drastically enough that firing may not give away a distant sniper's position, but one had not yet been invented that can make firing a gun sound like anything other than firing a gun. He was furious, feeling that he'd been cheated out of his dream, but once again, he had no recourse. He tossed the gun into a river when it proved too unwieldy to hide properly with the new attachment, then he moved on up the coast once more.

In Boston proper, he found next to no yachts at all, with most of them having already travelled further south in search of a more pleasant summer climate, and of the few there, none of them bore any resemblance to his Akista. Amidst mounting frustration, he carried on to the last coastal town he'd heard of holding a decent fleet of yachts—a town with a name weighed

down by its history. A name that brought dark memories back for Carl Panzram—Salem.

It was 18th July 1922, when Carl strolled into town. A beautiful day without a cloud in the sky, tempered by a gentle sea breeze that kept everyone comfortable as they went about their business. George Henry McMahon was one of those comfortable people, living a safe and comfortable life in a safe neighbourhood where kids like him were free to roam without fear. He lived on Boston Street, right along from where Carl rolled into town, and he was eleven years old. He'd spent most of the day lingering around the neighbourhood restaurant to stay out of the sun, chatting with friends as they passed by and doing the odd job around the place in exchange for shelter. Margaret Lyons, the owner of the nameless restaurant, was happy to have the boy around. He lived two houses down from her, and he'd grown up trailing along behind her children, who'd all grown up and moved away. He was a nice little reminder of that part of her life, and she had something of a soft spot for him, even if she was careful not to let him know that. A little after two in the afternoon, the restaurant ran out of milk for the coffees that they doled out for free to paying customers, so George was handed 15 cents and sent off to the corner store to pick up a bottle to keep them going until the dinner rush was over.

George had a little basket to carry groceries in, and he fetched that from the cloakroom before heading out onto Boston Street. He'd barely made it a few steps down the road before a voice called out to him, 'What's that you got there?'

He turned around to take in the uncommon sight of a stranger—a massive man dressed in a blue suit and wearing a cap. 'That's my shopping pail, mister. I'm fetching some milk from the store.'

'Could you walk me? I don't know my way around town yet.'

Carl and the boy strolled along the street together chatting away. Carl learned every detail of the boy's life as he blurted it

out in a rush, and he repaid the favour with a few brief tales of faraway places.

The A&P Store was owned by George's aunt, which was one of the reasons Mrs Lyons trusted him not to fool her around when he was sent there. George's aunt and the clerk greeted him and his guest warmly when they arrived. Carl chatted for a spell with the clerk, purchased a cola and a magazine for himself and another soda pop to thank the boy for his directions.

Back outside in the sunshine, Carl and the boy enjoyed their beverages then handed the bottles back in for change. They were about to part ways when Carl caught George by the arm and said, 'How would you like to make 50 cents?'

Half a dollar was a lot of money for an 11-year-old in those days. That wasn't an unfair wage for some of the jobs that adults did. He had some trepidation about abandoning his milk-fetching task half done, but with 50 cents he could always buy more milk. He nodded his head and Carl took off walking, fast enough that George had to scamper to catch up.

There was a trolley running through Salem in those days, and Carl had hopped on board and paid their fare before George even had a chance to comment. He'd lived a sheltered life up until now, and this seemed like a grand adventure to the boy rather than a source of any trepidation. He held onto Carl's sleeve and watched the town he knew so well rolling by.

Carl wouldn't tell him where they were headed, but he had a jovial tone that made George think that the secrecy was about not spoiling the surprise rather than anything sinister. About a mile from where they boarded, they exited the trolley in a deserted section of the town. George might have felt some inkling that things were awry then, but the twinkling promise of 50 cents was still there in his mind, just out of reach. The trolley rolled off, and he felt the comforting grip of Carl's hand on his arm once more. 'I'm going to kill you. I'm going to sodomise you until you die. I'm going to smash in your skull until your brain leaks out your ears. Do you understand me?'

George did not understand him. These things were so far outside of the world he knew, that it was as if Carl were speaking a whole other language. He didn't understand what was happening as Carl dragged him off towards the edge of town. He didn't understand as Carl stripped him out of his clothes, laughing in his face as he tried to fight off the intruding fingers and grasping hands. It was only when Carl had him pinned to the gravel by his throat and started pushing inside him that George finally understood what was happening, and even then it was only on the primal level. What was happening to him was pain. Pain without pause and without end. For three hours, Carl took his time raping the boy, revelling in his screams and his whimpers. There was nobody in that part of town to hear them, and it was as close to the sweet memory of that little African boy in Angola as Carl could recreate when his screaming echoed off the crumbling walls. At the end of it, he smashed the little boy's skull against a rock until he died, even though George had stopped resisting him somewhere about the end of the first hour. With the boy dead, Carl cleaned himself up and stuffed several sheets of paper that he'd torn out of his magazine down the boy's throat. There didn't seem to be any particular reason for him to do this beyond marking himself as the man who'd met George's aunt earlier in the day, but he did it nonetheless. Each time that he killed, he seemed to add some new twist to keep things exciting, to change his signature so that he was harder for the police to track.

Instead of just abandoning George, he gathered some tree branches and covered up the body to make it harder to find before leaving Salem entirely. Carl had no illusions about how long it would take for George's body to be discovered, and when a pair of witnesses spotted him high-tailing it away from the abandoned stretch of town, he looked almost panicked, jogging along with his ragged magazine flapping in one hand.

On the 21st July, three days later, George's body was discovered on the edge of town amidst a hunt for the missing

boy. The Salem police rounded up a posse of locals and roamed the streets searching for any strangers to the town and detaining them. A half dozen men who were just passing through town were arrested, but the witnesses from Boston Road were not able to identify any of them as the man they'd seen with George on the day of his disappearance.

The murder made headline news, not only in the local papers but the nationals, too. For a couple of weeks, the whole world knew George McMahon's name. Then, incrementally, he was forgotten. The manhunt ground to a halt after a local paedophile was lynched three weeks later, and while the police continued to search for leads, none were forthcoming.

The perpetrator of the terrible crime had strolled back down the coast to New York, and more specifically, Westchester County, to finish up his yacht-hunting expedition before his reserves of cash ran completely dry. Carl had become accustomed to a degree of comfort by this point in his life, and while it hadn't made him soft, it definitely made him more amenable to settling down, at least through the worst of winter.

In the early days of 1923, 'John O'Leary' managed to secure himself a job working as a night watchman at the Abecco Mill Company at 220 Yonkers Avenue. Presumably, the hiring manager thought, quite rightly, that nobody would be foolish enough to try to break into the building if they had to contend with Carl Panzram. He rented an apartment nearby, and for the second time in his entire life, he found himself with a permanent residence to call his own and a bed to lay his head on each morning. The night shifts were long and boring, with not even a hint of the violence and action that Carl craved, but they came with some small recompenses. One of the teenage boys at the mill lingered after his shift was over, sharing a smoke with Carl each night before his work began. Before long, a bottle of moonshine found itself added to the equation, and the early parts of Carl's shifts turned into a social event that he looked forward to. Eventually, the tension became too much for Carl. As

much as he wanted to keep the job, he wanted this boy, George Walosin, even more.

In the unlit factory, he drove the boy to his knees and mounted him. But to his surprise, George didn't try to fight back. In fact, he seemed in a hurry to get out of his clothes and get on with things. For the first time in his life, Carl had consensual sex with another man. Afterwards, Carl didn't know what to do with himself. He was awkward and uncomfortable when George tried to kiss him good night. All of the pent-up energy that had been building through the long weeks of their flirtation had dissipated, leaving him as empty as the creaking building around them. George was a little let down by the lack of affection, but it didn't stop him coming back the next night, and the next, and the next. Before long, sex with George had become a part of Carl's regular routine. They'd drink and smoke, find a quiet corner where they could indulge themselves for an hour or so, and then he'd send George off, often with a spare dollar in his pocket to encourage him to keep quiet about things even though that was completely unnecessary.

George was kind to Carl in a way that he was entirely unprepared for, and when he began to develop soft feelings for the boy, it created another philosophical crisis for the man. His worldview was based entirely on the idea that the strong and the powerful dominated the weak and the naïve, yet here he was romancing this boy like he was in some story at the motion pictures. It shook him. If the world was not the way that he'd imagined it, then his actions could not be so easily justified. If there were another way that he could be living, taking it easy in a cushy job like this, having the sex that he wanted when he wanted it without anyone getting hurt, then that meant that he was a monster. The only monster in a world full of normal people, not the only honest man in a world full of monsters who tried to dress themselves up as something more.

These were the kind of mental dichotomies that Carl had committed to a life spent outside of the law to avoid, and now he

had to face them every night as George gave in willingly to his advances. Just a few months before arriving in Yonkers, Carl had raped and murdered a prepubescent boy to achieve the same kind of gratification that it seemed everyone else managed just by stumbling through a relationship. And now, here he was, satisfied with a life on the right side of the law, with some boy who liked him back and didn't need to be forced into any manner of depravity. He was waking up in the morning truly content. It was too much for him to tolerate. The memories of what he'd done, of what he was, ate at him night and day, tainting every moment of peace that he should've been revelling in. Reminding him that this place and this boy could only ever be temporary.

When spring came around and the days started warming up again, Carl abandoned his apartment and quit his job with no notice. If he'd left George behind without so much as a goodbye, then the boy still would've been miles ahead of any other man that Carl had ever become enamoured with, but Carl was too greedy for that. He wanted his wild and wanton life, and he wanted his boy along with him for the ride. This presented a problem. George was a sheltered boy, despite his inclinations forcing him into contact with a shadowy world where he was entirely out of his depth. At the first sign of trouble, Carl wasn't sure which way he was likely to jump, and the last thing that he wanted was to put his young lover to death just because he couldn't live with the things that Carl had to do to maintain his lifestyle. The two of them made a pact. Carl was going to go away for a time to put things into place, and when summer came on properly, he would come back to collect George and take him away from all of this mediocrity. He finally deigned to give the boy a kiss before he left, but it felt wrong to both of them. Carl's version of affection had always been animalistic. Playing soft really did not suit him.

If he wanted to be true to who he was, then it was clear that Carl could not stay fixed in one place, where evidence against him could be easily gathered and his crimes just as easily pinned

on him, but as technology advanced, it actually became harder and harder for a criminal to move around America unnoticed. Cars were still a new invention that Carl had no familiarity with, and the infrastructure still wasn't in place for reliable interstate travel. More pressingly, the railroads that had always been Carl's favoured method of transportation were becoming increasingly inhospitable. As organised crime had come to prominence, the railroads had been identified as one of their primary modes of smuggling illegal goods across state lines. The old railroad bulls that Carl had been so used to knocking around were gradually being supplemented and replaced with trained law enforcement officers of various stripes—men who wouldn't hesitate to open fire on a hobo just for riding the rails.

The community of homeless drifters who had always sheltered Carl was being driven apart in every direction, and without the rails to link up their scattered camps, news could not travel and groups could not gather the way that they used to. Making matters worse for the hobos, crop failures across what would soon become the dustbowl were driving more and more normal people into an itinerant lifestyle. The yeggs and their Angelinas were nowhere to be seen, driven out of the underbelly that they used to occupy by an influx of decent people who had no time for the sickening perverts and career criminals who'd once been its mainstay. Times were changing, and Carl found himself helpless in the face of the crushing weight of history.

The only place he could be truly free to roam the way that he had before, was on the ocean. So, he returned to his original plan to steal a ship and refit it to look like the Akista. He finally found what he was looking for moored off a marina in Providence, Rhode Island. The new ship was a poor match for the Akista, but Carl was starting to suspect that it would be easier to pay somebody to forge the details of the ship on his papers than to find a matching craft. The yawl that he procured was a beauty of a ship, 38 feet long and outfitted with all of the latest modern conveniences. With his hard-earned skills at sea, Carl was able

to operate the whole ship without a crew and without much more effort than that with which a regular man might stroll down the street. In the dead of night, he set his course for familiar waters, and when the dawn came, he was already well on his way to Long Island Sound, where the bodies of the victims from his last yachting trip still lay in the deep, dark waters, being picked at by the flounders.

With no more fear of the ocean, Carl also lost his fear of capture. In the ship he had stolen, and with his skills as a seaman, there wasn't a single police force in the world that stood a chance of capturing him, and he'd lay good money at even odds on his chances against any of the navies on the ocean too. He had plans in place to collect George soon, but until then, he wanted to get started gathering himself a little nest-egg to make their life at sea a little more comfortable. He wanted George to experience all the highs of living the life of an outlaw without ever showing him how the sausage was made.

The River Pirate

Moored on a jetty near New Haven, Connecticut, Carl began his latest crime spree. He would trawl the streets at night for men to rape and rob, and he made enough to get by from their pocketbooks alone, but it wasn't enough to keep him and George afloat through the whole summer. Before long, temptation began to tickle at him once more. He started to scout out large homes where he might get a haul comparable to the Taft robbery. As tempting as each of those miniature mansions was, he'd learned a little lesson the last time he attempted to rob one, and he was cautious. With George waiting for him up in Yonkers, he didn't want to end up back in jail, so he scaled back his ideas a little. Instead of targeting the super wealthy like he had last time, he hit a few middle-class homes that the police would be less concerned about. The hauls were in no way comparable to the ridiculous wealth that he'd acquired robbing the ex-president, but the risks were still far too high. Hauling everything that he'd taken from the homes back to his yacht was nerve-wracking, and before long, he was eyeing up waterfront properties exclusively.

That was when he struck upon a better idea. The vast majority of the yachts moored around these wealthy maritime summer towns were left abandoned through the night, when

their owners retired to the comfort of their own homes by dinghy. Many items of value were left aboard the ships, trusting to their position away from the shore to protect them from petty thieves. After all, how many burglars were there in the world who knew how to sail? It was a veritable bounty for Carl. Not as much as if he had hit one of their homes, but considerably more than he could acquire by robbing any individual on the street. On top of the cash value of the furs, jewellery and clothes that he'd pilfered, Carl also managed to secure a decent amount of liquor through these robberies, as people were inclined to keep their illegal alcohol on board, where it could be easily tossed overboard if the police sailed by rather than risk it being discovered in their homes. None of that compared to his greatest find, however. Off the coast of Premium Port, Carl discovered a .38-calibre pistol in one of the anchored yachts, and with just a little digging through the ship's papers, he was able to identify both the gun and the yacht as belonging to the police commissioner of New Rochelle. It wasn't as sweet as screwing over one of the specific policemen who'd arrested him over the years, but it still brought Carl some measure of vengeful satisfaction to think that he would be committing murders with the police chief's gun.

As the summer reached its peak and June rolled around, Carl finally took the yawl up the coast to meet George. By that point, George had almost given up all hope of ever seeing his lover again. He was shocked when Carl showed up out of the blue and asked him if he was ready to go, but not so shocked that he didn't hand in his notice and kiss his mother goodbye, telling her that he'd found a job on a sailing ship that would let him travel just like he'd always wanted to.

With George's goodbyes said, the couple took a little time to restock the supplies that Carl hadn't already been able to refill with his piracy. Then, on the 25th June, they set sail due north up the Hudson River towards Peekskill. George was completely overwhelmed by the yacht and all of the riches that it contained.

He couldn't believe that Carl had been working as a night watchman when he clearly came from money.

For the first time in his life, Carl had found somebody to whom he was uncomfortable lying, but he couldn't share the truth with George if he expected him to stay by his side. He bumbled through an explanation involving problems with his papers and his time out of the country, but that just led to more questions that he didn't want to answer. Eventually, he forced George down onto his knees and climbed on top of him rather than trying to navigate the conversation for a moment longer. As he tried to fuck all of his problems away, the ship spun slowly in the current, adrift and lost with nobody at the helm.

Change had always been a constant in Carl's life, but for the first time, the temporary nature of his situation was troubling to him. Everything was going to end abruptly when George discovered the truth about him, and Carl had no illusions that he could keep his true self hidden forever in such close proximity and with such an impediment to his usual skills at deception. All that he could do was try to keep things afloat for as long as possible.

They dawdled upriver, travelling only 50 miles in two days, and it soon became apparent to Carl that George was not enjoying himself at sea. The boy suffered badly from seasickness, he couldn't find his balance and his constant complaints were beginning to wear on the older man. In a snap decision, Carl decided to sell the yacht and find some other way to 'settle down' with young George. He moored the ship in a bay near Kingston, to repaint the hull and rename her before taking the ship towards town and coming ashore. He spent the day wandering the usual hangouts searching for the ideal buyer for the yacht, one who had a decent amount of money but wasn't overly concerned about the provenance of the things that they bought with that money. Towards evening, he was introduced to a man who seemed to have the loose morals and cash that were required, and he ran him out in a dinghy to take a look at his potential purchase. On

the night of 27th June, the trio of men settled on the deck of the ship and began drinking while they hashed out the details of the deal. The buyer had flashed enough cash on land to get Carl to pursue him, but now he seemed reluctant to part with any of it despite the ship being entirely to his liking. George thought that this was just a ploy to try and haggle them down on the price, but Carl was more suspicious of the stranger's intentions. He had been on the other side of this equation often enough to recognise the signs. When the cocky 'buyer' suggested that he might take the yacht off their hands for nothing, George didn't know what he meant, and when he pulled a gun on the men, fear pinned the 15-year-old in place. There was no fear in Carl. If there ever had been, it had been burned away in the crucible of suffering long ago. Before the robber could even finish his threat, Carl had his own pistol drawn and had put a bullet through his head.

That initial moment of fear in George turned into terrified paralysis. All he could do was watch in horror as his lover lumbered over and rifled through the dead man's pockets for the cash he'd seen earlier. Most of it proved to be shoddy counterfeit bills, but there was enough that the evening hadn't been a complete waste.

'Fetch me out the spare anchor, Georgie.'

The boy stared at him like he was seeing Carl for the very first time. Like he had seen behind the mask of sanity to the reality of the man he'd thought was his soulmate. He did not move. 'Fetch me out the spare anchor, we've got to get rid of him.'

George stumbled to his feet, but he still couldn't quite bring himself to believe what his eyes were seeing. 'You shot him.'

'It was him or us, and I like us better.' Carl could lie to George about a lot of things, but he couldn't bring himself to give a damn about some petty thief who'd come for him with a pistol.

'We need to tell the police.'

Carl scoffed. 'You think the police believe the word of men like us? They'll say we lured him out here to sodomise him and

take his money. You can't trust the police, Georgie. They'll try to stick anything on you that they can.'

George couldn't take his eyes off the corpse. 'But he's dead.'

'And we ain't. We've got to get rid of him and keep on moving if we don't want to spend the rest of our days breaking rocks.'

Carl eventually fetched out the little lead anchor-weight himself when it became apparent that George was going to be completely useless. He bound it to the dead man's leg and cast him overboard. George eventually sank back into his seat as Carl went through the necessary processes to get them floating back down the river. He had no idea who their visitor had told about his plans for the evening, and while Carl had no fear of facing off against any man, he didn't want to see that look on George's face again.

They sailed downriver through the night, catching only the odd breeze and making no real effort to get anywhere. George slept fitfully through the night, awakening each time to see Carl's dark eyes peering out at him from under his heavy brow, watching and waiting to see what he planned to do next. They were barely three days into their journey together and everything was already falling apart, but Carl still held onto some hope that things could be salvaged. Unlike most of his murders, this one was unarguably in self-defence, and if he acted like he was a bit more torn up about it, then maybe he could convince George that it was his first time.

When the dawn came, George snapped awake and realised that they had stopped drifting. There was no sign of Carl anywhere. The man had gone ashore to steal some fishing nets on the assumption that being able to supplement their resources with a fresh catch might mean they didn't have to come ashore as often. He planned on taking George out a distance onto the open water and working on him until he could be sure which way the boy was going to jump when he finally had a chance to talk to someone on land. All that he needed was a little bit of time to

make sure that George would either keep his mouth shut or tell the story the way that Carl wanted him to tell it.

George never gave him the opportunity. While Carl was still off on the dock-fronts of Poughkeepsie committing yet another crime, George leapt from the ship into the water and swam for his life, aiming not for the nearest shore of the Hudson but the opposite one. The current dragged him downriver to Newburgh, where the local fisherman spotted him and helped to drag him ashore. The first words out of his mouth once he could draw a breath were, 'Police. I need the police.'

He reported that Carl had brought him on-board the ship under false pretences, claiming that he'd been promised a job, and that Carl had then raped him repeatedly for the duration of their time together until he'd managed to escape that morning. Most importantly, he reported the murder of the unnamed man to the police and gave them the directions they needed to retrieve the body. At the time, that information wasn't much use to the police—the body may as well have been on the dark side of the moon for all that they could reach it at the bottom of the Hudson. But George's testimony was good enough for them. They put out an alert to every port town up and down the river to be on the lookout for Captain John O'Leary.

On his return to the yacht, Carl quickly realised that George had abandoned him. After so many years and so many petty betrayals, you wouldn't think that the man could feel anything at all, but he was devastated. This was everything that he'd feared might come to pass. George hadn't just rejected him for who he really was, he'd been so terrified that he ran straight into the arms of the law. Carl spent a few hours trawling the streets of Poughkeepsie looking for the boy, but through it all his anxiety kept on growing. Every moment that he stayed still brought him closer to capture. He needed to move on. When the pressure finally got too much for him, Carl dashed back to his boat and set sail, going with the flow of the river to put as much distance as

possible between himself and whatever accusations George was flinging about.

By nightfall, Carl had made it as far as the village of Nyack, where he promptly ran out of steam. He docked at Peterson Boat Yard and got himself settled in for the night without talking to a single soul except for the dockmaster. He went down to the narrow bed beneath deck and lay himself down in it. When he'd been sailing alone, that bed had always felt too small for his massive frame, but now that he, again, had nobody to share it with, it felt empty. He curled up around the empty space where George used to lie and sank down into the darkness of sleep.

He woke up looking down the business end of a shotgun. The Nyack police may not have been the best or brightest in all of America, but they were no fools. When a call went up and down the river to keep an eye out for a man, they had the good sense to check in with all the dockmasters before anybody could sail off. In the world that Carl had known before his trip abroad, police departments did not speak to one another, and they sure as hell didn't give each other a quick ring on the telephone when someone they were hunting moved on to the next jurisdiction.

In the face of organised crime, organised law enforcement was finally finding its footing in America. All of the old tricks that had kept Carl and his hobo buddies free were useless in the face of it, and they had yet to learn the new tricks that the bootleggers were using to sidestep the law. The Nyack police confiscated the yawl and arrested John O'Leary on charges of sodomy, burglary and robbery—the only things that the Newburgh police knew for certain that they could charge using their sole witness. John listed his occupation as 'seafarer', his age as 40, and his place of birth as Nevada. In truth, Carl was only 32, but a hard life had given him the appearance of a much older man, so nobody doubted his story. It isn't clear if Carl even knew his age by this point, after so many years roaming the world without a home or any need for a calendar. It is entirely possible that he believed

the lies he was spinning. It would explain why he never tripped over them.

The next day, a pair of Yonkers detectives came upon the municipal ferry to claim John O'Leary and impound his yacht officially before taking him downriver to Yonkers jail to await trial. Carl went along quietly without any of his usual rancour, still distraught at the depth of George's betrayal. His dazed state didn't last long. Once he was back in the familiar territory of a prison, all his old instincts began to reassert themselves. Just like his attempts to have sex with little girls in Angola, this was just another reinforcement that he could never have any sort of normal life or take any sort of normal joy in his own choices. George had betrayed him because George was weak and soft. He hadn't had the courage to admit that murder, sodomy and robbery were man's natural state. There was still a strain of that same awful weakness in Carl too, the one that made him shy away from thoughts of revenge on George, even though he had turned Carl over to the authorities. The tiny human spark that still dwelled somewhere down in his soul made him turn that hatred inwards instead. For the first time, Carl finally hated himself as much as he hated the rest of the human race.

On the 2nd July, mere days after being confined, Carl attempted a breakout. With five other prisoners enlisted to assist him in his plans, they spent the day breaking apart their beds to use the metal frames as tools to pry away the mortar around their window bars and escape. They began their work at night, with the sounds of their scraping disguised by the hooting and hollering of the other prisoners. With his cellmate, Fred Federoff, Carl was making good progress, having pried one bar free, when they were discovered during a routine cell inspection by the guards. Carl tried to charge the guards, using the bar from the window as a bludgeon, but he was overpowered by the weight of numbers and hauled off to solitary confinement. The other prisoners attempting to escape were caught soon after, but while they were all returned to their cells not long afterwards, Carl

remained down in the hole. They'd all pointed to him as the ringleader of their little plot, so he took the burden of punishment for it.

Compared to some of the places Carl had been jailed before, solitary confinement in Yonkers was like a luxury hotel. They even fed him. It was the ideal place for him to sit in peace and think about his next move.

Since his betrayal in San Francisco, Carl had refused to even speak to a lawyer throughout all of his later convictions. Even in the courtroom, he would sit beside his publicly appointed defender and ignore them entirely, but that didn't mean that he couldn't see the value in having some man in a suit with deep pockets on his side. He requested to speak not with a court-appointed lawyer but with a man from one of the better firms in Yonkers. Mr Cashin had never heard of the 'John O'Leary' character who was trying to contact him, but he attended the jail out of pure curiosity as to how such a reviled figure had happened by his name.

Carl never shared that little tidbit, but he did manage to convince Cashin that he was not the ruffian that the police were making him out to be. He confessed that he made his money in oil—and was able to furnish that story with enough details from his time in Angola that it seemed plausible—but was unable to access any of his wealth due to being confined on the other side of America from his holdings in California. Carl's bail had been set at $5,000, an amount that he claimed he'd normally have no trouble raising, but the only asset that he had here in New York State was his yacht, the Akista. This was when Cashin began to take an interest in Carl's stories. Cashin had been in the market for a yacht for several years but had never quite managed to pull together enough money in a lump sum to buy one. Carl offered him up the opportunity on a silver platter. He would sign over his fully outfitted yacht, worth more than $10,000, to Cashin in exchange for the man paying his bail. Once he was out, he would

have no trouble contacting his people and getting some money transferred so that he could live comfortably until his trial date.

It was a gamble from Cashin's perspective, but one with two fairly appealing prospects. Even if O'Leary skipped out on bail, $5,000 wasn't a bad price to pay for a yacht, and it was more than reasonable for the yacht described in the modified Akista papers. The two men shook on the deal, and before the day was out Carl was a free man once more.

Cashin went directly to collect his new yacht from Nyack, sailing it down to New York with a hired crew so that he could register it properly with the port authority. This had been a long time coming for the man, and he was looking forward to rubbing shoulders with all of the big boys from New York in the various sailing clubs, where so many of the lawyers liked to congregate. He strolled into the port authority with his papers in hand and a big grin on his face. It only took the officials about 5 minutes to wipe away his smile. A quick inspection of the yacht showed that it didn't match the papers, and after consulting with their own records it didn't take long to realise that the papers had been doctored, too. The real name of the ship was soon uncovered, as was the fact that it had been stolen down in Providence. The police arrived to confiscate the stolen property and give Cashin a talking down.

Enraged, Cashin caught the first ferry back up the Hudson and stormed into the hotel O'Leary had booked himself into, only to discover that the man had skipped out of there on the first night, and now was nowhere to be found. Yonkers police were of no help to Cashin either. In fact, he was something of a joke to them—a lawyer who had been outsmarted by his own client.

Dannemora

In June of 1923, a yacht went missing from Larchmont Marina, just a few miles from the Connecticut border. The ship belonged to a doctor by the name of Charles Paine, and while he reported the loss immediately to the authorities, he wasn't exactly heartbroken. The ship was in a state of dreadful disrepair, and the man half-hoped that it would be sunk so that he might recoup some of his losses through an insurance claim.

Carl struggled with the ship all the way down to New Rochelle before the rudder locked and the ship crashed into the rocks offshore. He emerged from the ocean drenched and furious to see his plans run aground once more. Every time that he felt like he was making some progress, he would end up battered against the rocks by fate. He was ready to admit culpability for his last disaster—showing so much weakness and bringing along his boy, George, along for the ride—but how was he to know that the shining white yacht that he'd made off with would be riddled with rot from the water-level down? It wasn't like he could put them in dry-dock before he made his selection.

After lounging in the sun for a time to dry out, Carl headed back to Larchmont to take a second swing. That ship may have been worse than useless, but there had been plenty more just

waiting to get snatched up in town. Larchmont was a favoured holiday destination for the Manhattan elite, a home away from home for many of the yacht-owning crowd—exactly the kind of people that Carl loved to rob the most. And while the ship he settled on was less than ideal, he could still take a decent haul just going ship to ship with a sack.

Once again, fate seemed determined to thwart his plans. By the time he arrived back in town, a warm summer's evening had fallen, and every yacht was out on the water, with the laughter and music of their festivities echoing back across to land. They were all out there, with all of their money and good living, just out of Carl's reach. If he wasn't already enraged, this would have been enough to push him over the edge. As it was, it was enough to make him act like the rash young man he used to be.

The yachts and all of their wealth may have been out of reach, but those rich scumbags had to be coming into town somewhere. None of them could sail worth a damn, and none of these yachts had ever docked down by Manhattan, so the boats were obviously left up here in Larchmont, just waiting for the cream of society to show up and take them out. Carl didn't know much about cars, but he knew that the road up this way was rough-going in places, even on foot. His money was on all of the wealthy patrons of Larchmont catching a train into town. He crept up to the train station after night had properly fallen and made his way around it, peering through windows to see if his suspicions were correct. The luggage racks inside were stuffed full of cases and the game was on. After a few failed attempts to force the doors, Carl switched tactics, borrowing the fire axe from around on the platform and using it to smash in one of the high windows. Scrambling through the gap and slicing himself up pretty well on the broken glass as he did so, Carl made his way inside the station and started digging through the cases. Furs, tuxedos and jewellery abounded, enough wealth to keep him going for months if not years. It was the kind of haul he hadn't seen since he robbed Taft. Carl was like a kid in a candy store,

tearing open cases everywhere he went and marvelling at their contents. From these foundations he might even be able to buy another yacht legitimately, sail all the way down to South America like he had always planned. He was so lost in the excitement of his find that he didn't realise the cop was behind him until he heard the click of a pistol-hammer being cocked. Most men would freeze at that sound, almost all of them would at least pause. Carl did not. He scooped up the axe from where he'd left it in reach and charged at the policeman, roaring in fury. It was like a scene out of a nightmare for the poor village policeman, this lumbering wild-eyed giant of a man coming at him with a lethal-looking axe at the ready. He dropped his gun in fright and would have turned and ran if it wouldn't have cost him his life. At the last moment, he dashed at Carl and tried to wrestle the axe out of his hands.

On any normal day, Carl would have torn through this poor man in moments, but that night things were anything but normal. The cop was flooded with adrenaline, well aware that he was fighting for his life, and desperate to fend this beast of a man off. Meanwhile, Carl had already been through hell. During the 48 hours since he last slept, he'd survived a shipwreck, swum to shore and hiked for miles up the coast to get back to where he started. He was physically and mentally exhausted, but more than that, his confidence had been shaken by how things had unfolded with George. He still couldn't shake the seed of doubt that had been planted in him, and without his confidence, he was nothing. Step by step, he was driven back into the train station and against his will. His knees began to bend as he strained against the policeman. He was so surprised at his own weakness that when he was pushed down to the floor in the struggle he just stayed there.

He'd been dreaming of living a normal life, of being a normal man. Now he got to experience what it was like to be brought down to normalcy, with none of the power that he'd been wielding since the heydays of his youth. The cop pulled the axe

from his hands and wrestled the handcuffs onto him, with Carl screaming and bucking impotently all the way.

By dawn, he was locked up in the Larchmont Police Department's single-cell station, sleeping deeply on a stained and narrow pallet. During his interrogation, it came out that he'd committed other robberies in Larchmont, and they linked him to a few other burglaries in nearby towns too. In the village court later that morning, Judge Schafer set bail for 'John O'Leary' at $5,000 and sent him on his way. The locals prepared to ship Carl off to county jail to await his trial, but Carl didn't want to go. There was still a spate of other crimes that he'd committed in local towns that he knew would be pinned on him if he hung around until his trial date. He needed to get out of New York State and escape somewhere that he had a lesser sentence to serve. When one of the policemen tried to forcibly drag him out of his cell, Carl snapped that he'd killed cops for less, and that was enough to bring the whole process of transferring him to jail to a grinding halt. Carl was thrown back into interrogation, and the local police went at him day and night until he admitted that he was an escaped prisoner from Oregon who had ducked out on a 17-year sentence for killing a police officer. It was a shocking story, almost unbelievable. The local police suspected that Carl was 'a chiseller', someone who confessed to crimes that they hadn't committed because they liked the attention, but Officer Richard Grube, the cop who first caught him in Larchmont, was quick to come to Carl's defence. He believed that Carl would have murdered him without a second thought in that train station if he had been able, and he championed Carl's case to his chief of police.

A letter was sent to Oregon detailing the confession that had been received, a list of the man's known aliases, and a description of Carl Panzram. By this stage in his life, Carl had a thick black moustache that gave him the appearance of a perpetual sneer. Scars covered his body from his many brawls and he had a pair of eagles tattooed on his chest and an anchor

on his arm. While many of these features were later additions that came after his time in Oregon, he was still easily recognisable from the description of his attitude and demeanour.

Warden Johnson Smith of Oregon State Penitentiary telegrammed back on August 29th to say, 'Jeff Baldwin is wanted very badly in Oregon. His was a noted case that attracted considerable attention all over the Pacific Coast and we are very anxious to send an officer for him at the earliest possible moment.'

Under the name of Baldwin, Carl still had 14 years left on his sentence in Oregon, and there was a $500 reward for information leading to his capture, which Carl tried to claim. He'd provided the information leading to his own identification after all. The cops were amused, but not amused enough to give him a penny. They sent off the relevant paperwork to Oregon for them to make their claim on Carl and then moved on as though he was just any other criminal.

Two weeks later, in the middle of September 1923, Carl had his day in court for the burglary charge. Recognising that the evidence against him was insurmountable, he arranged to meet with the district attorney and come to an arrangement. In exchange for a lighter sentence, he agreed to plead guilty to the burglary, but once again he found himself betrayed by the lawyers. After his guilty plea was made, the DA immediately started pushing for the maximum 5-year sentence, citing Carl's history as a violent offender as all the reason he needed to keep the man off the streets. It did not help Carl's case that he went berserk in the courtroom following that little speech, threatening to bring down every imaginable pain on the lawyer who had tricked him. He received that 5-year sentence, and the next day, he was shipped off to Sing Sing prison as 'John O'Leary'.

His stay there was brief. It was a general population prison, with a mix of violent and non-violent criminals from all over New York, an even mix of people who'd devoted themselves to the life of crime, like Carl, and of people who just happened to have had

a run of bad luck or bad choices—citizens who were expected to return to their regular lives and never offend against the law again. For Carl, they were prey. He soon established himself as the power in Sing Sing, dominating the existing tough guys and even bullying the gangsters. The prisoners couldn't control him, and the guards were afraid to even try. When one guard tried to pull him off a gunsel that he was raping, Carl turned his lusty attentions on him instead, and it took four men to drag him off before he could bring his intended climax to pass. It was clear to the administration that Sing Sing just wasn't a tough enough prison to hold John O'Leary, so in October, he was transferred to the deepest, darkest hole that the state of New York had available: upstate New York's Clinton prison, also known as 'Dannemora.'

Dannemora was just 10 miles from the Canadian border, and it drew almost all of its staff from a local village of French-Canadians, who couldn't have spoken to their prisoners even if they wanted to. They didn't want to. Silence was the rule within the prison's looming walls—silence enforced with metal spike-tipped canes that every guard carried and applied liberally. Generation after generation of the French-speaking villagers had served as prison guards in Dannemora, passing down their own brutal traditions and training their children to take their places once age began to set in. The prison itself was more castle than penitentiary, with walls that stretched 30 feet up and burrowed 20 feet below the surface of the yard to prevent anyone from digging their way out. It was a world apart from the prisons where most Americans were confined, like something out of a lascivious history book about the dungeons of old Europe.

When Carl arrived, he was stripped naked and washed down with snow-melt. All of his belongings were confiscated and shared out amongst the guards. Then, the first of many beatings were applied, just to teach him his place in the order of things. He was so beleaguered and punch-drunk by the time he was delivered to the warden's offices to complete his paperwork that

he gave his name as Carl Panzram instead of one of his aliases. The warden, having no idea who the man was, filed him under that name and sent him off to his cell.

The screaming never stopped in Dannemora. Carl was surrounded by inmates who were sworn to silence by the guards and subjected to brutal tortures if they ever stepped out of line, but across on the other side of the courtyard was the State Hospital for the Criminally Insane, where Dannemora's least fortunate sons ended up after the torment they were exposed to each day broke their minds. Carl could hear them shrieking all through the night and day, a cacophony that wouldn't have been out of place in the depths of Hell.

Carl fit right in. Within a week of his arrival, he had constructed a firebomb in the workshops that he intended to burn the whole place down with. If it had killed half the inmates, he wouldn't have cared all that much, as long as it forced the guards to evacuate the rest and give him his opportunity to make a run for it. The guards found and dismantled the bomb before it could be detonated, entirely by luck, and Carl was brutalised on the basis of their suspicions that he'd been involved in building it. It was nothing compared to the torture that he'd faced in previous prisons, but the stinging jabs of those spike-tipped canes were enough to raise his ire.

In his second week in Dannemora, he crept up behind a guard where he sat sleeping and hit him in the head with a 10-pound club that he'd fashioned out of some furniture. The man dropped to the floor, and Carl assumed he was dead, but it later turned out that the guard had survived the concussion. From that day forward, that guard had motor control problems; he slurred his words and lost his train of thought whenever he was under any sort of stress. From then on, Carl was treated with the correct amount of respect by guards and inmates alike.

In his third week in Dannemora, Carl devised a plan to get out under the cover of darkness. He gathered up the various supplies that were meant to be used for the tending of the kitchen

gardens and bound them together with twine into a rickety ladder 30 feet long. The guards were known to trust the walls to keep the prisoners confined, never troubling to keep watch over the yard at night, so once Carl had flexed his incredible shoulders and lifted his cell door right off its hinges, it was no trouble at all to collect the ladder from where he'd left it and carry it out to the wall. His plan was simple: climb to the top of the wall, haul up the ladder, lower it outside and climb down to freedom. Of all his prison escapes, this was probably the most straightforward and certain to succeed. Unfortunately for Carl, his craftsmanship wasn't up to the same standards as his plotting. Everything went according to plan as he scurried across the yard in the dead of night and began his ascent, but when he reached the top of his ladder, one of the tools in the mid-section splintered apart. He toppled backwards on his ladder and fell the full 30 feet to land on a concrete step in the yard, breaking both of his ankles, legs and his spine. Worse yet, he ruptured his groin, with his organs bulging out between his legs like he was giving birth to his own innards. It was the worst agony that Carl had ever faced in his life, and all of the screams and sobbing that he'd pushed down inside himself throughout the years tore their way out of his throat. He lay there screaming all the way through the night, and nobody came to get him. Everybody assumed that the noise was nothing more than the criminally insane across the yard. All through the cold night he lay there, helpless, trying to push his own guts back up inside himself until the agony knocked him out.

When the morning came and a patrol strolled by, Carl was reduced to begging for help. All of his tough-guy façade had vanished in the face of the overwhelming pain. Four men gathered around him and hoisted him up by each limb, setting him off shrieking all over again. They carried him into the building as he babbled his thanks at them, as he begged for the doctor, as he wept at the overwhelming pain. He'd never seen the medical ward of Dannemora, so he assumed that it was where he

was headed, right up until the moment that the dark room of solitary confinement opened up in front of him. They threw him onto the dirt floor, and then all that he knew was darkness and pain.

When he next came back to awareness, nothing much had changed. He was still in darkness and agony. He remained in that cell as his bones stitched themselves back together in twisted new patterns and the bulge of strangulated organs between his legs became his new normal. It was a year and two months before he was finally dragged back out of the cell to limp bowlegged along to the hospital ward, every step drawing new crunching sounds from his ankles. During that long, agonising year, officials from Oregon had approached the prison in search of their missing man, planning to deport him back to Salem to serve out his sentence, but there was no record of either John O'Leary or Jeff Baldwin in their files. If the circumstances had been different, it was possible that the administrators might have put in the effort to backtrack and discover that their Carl Panzram was the same man, but as it was, those who suspected that connection had no intention of giving that broken man up when they weren't even halfway through tormenting him for his attempted escape yet. The Oregon prison agents went home empty-handed, and Carl continued to rot in solitary.

The doctor was hardened after years working the prison ward, but even he was appalled by the state that Carl was in. He helped the man into bed and quickly scheduled the surgery to fix his ruptured groin. Carl's legs were beyond his ability to fix. To repair the damage without the breaks being set would require dozens of new breaks to be made and for each fragment to be carefully re-aligned. It was the kind of surgery that only two or three doctors in the world could have performed at that time, and the man in Dannemora was most certainly not one of them. The surgery on Carl's groin was a success, with all of his internal organs returned to their normal place, but the guards were not content to stop there. At their behest, one of Carl's testicles was

surgically removed, on the basis that this might reduce his aggression, in the same way that dogs are fixed to make them more pliant. Needless to say, when Carl woke up after his surgery, the removal of part of his genitals did not make him calmer about the whole situation. He was absolutely furious, and if he hadn't been so drained by the whole experience it's likely that he would have murdered the doctor before the guards could drag him off and dump him back on his bed. He sank back down into another pain-fuelled nightmare almost as soon as he hit the pillows, blood leaking from the stitches that he had just burst, to stain the white sheets.

It was several days later that Carl recovered enough to sit up in bed and take food. Almost immediately he felt his strength returning and concerns about his sexual prowess developing. He'd lost one of the physical expressions of his manhood, and he had some very serious concerns that he wouldn't be able to perform the way he used to. So, it was with no small amount of worry that he climbed out of his own hospital bed and into the bed of another sleeping prisoner, to rape him. The doctor dashed into the room at the sound of screaming, and for a moment he didn't even understand what he was looking at. Then, he was horrified. He didn't have the strength or the courage to stop what Carl was doing, so he ran off to get the guards. By the time that they arrived, the deed was already done, and Carl's old, wicked grin had returned to his face. He may have been racked with pain every step that he took, but he was still every bit the monster that he'd always wanted to be.

He was tossed back into solitary confinement on the spot, and he remained there for the rest of his 5-year sentence, crawling around on his stomach like a snake rather than putting any weight on his legs. In that dark place, he became even more subhuman than before, incapable of any speech beyond snarling and of any thought beyond vengeance. He literally tried to bite the hand that fed him each time a meal was delivered, and he was starved for a week at a time each time he tried it.

So, the years rolled on for Carl, until one day without warning he was dragged back out into the light, scrubbed down with snow-melt, and dressed in the clothes that he'd been wearing when he arrived, now many sizes too big for him. It was 1928 when he took his first agonising steps out into the world again, but despite that pain, he didn't hesitate for even a moment. He had too much to do and too many plans to bring to fruition.

The Big Time

From Dannemora, Carl didn't have many choices that weren't south, but he pressed right on out of New York State as soon as possible, keen to put some distance between himself and his bad memories. In Philadelphia, he made his first real pit-stop. He'd laid many plans during his long years in solitary confinement, plans that would require considerable financing to bring to fruition. Where before he'd toyed with the idea of starting wars and other terrorist acts, he now set those stray thoughts into some sort of order. He identified a road tunnel that he planned to collapse at one end and fill with poisonous gas before robbing all of the people trapped inside. He planned to invest the money made from that job in the stock market, targeting businesses that would boom during wartime with his investments. He would then ignite a war with Britain by attacking American ships in the Panama Canal, where conflict was already simmering. The profits from these crimes would be sufficient to keep him in comfort until the end of his days in some African backwater where he could set himself up as a warlord king and indulge in the kind of pleasures that more civilised places would frown upon. He would need some start-up money to get the ball rolling on all of these plans, so he intended on

committing a few burglaries to acquire the initial funds. Before any of that though, he planned to find a little bit of the special pleasure that he could only take in freedom, a taster of what he was going to make his future into.

On Point House Road in Philadelphia, he found a little boy, named Alexander Uszacke, delivering newspapers. Alexander was the son of Eastern European immigrants of unknown provenance and could speak very little English, but for what Carl was trying to communicate, only a little English was required. Alexander went along with Carl to an abandoned warehouse near the edge of town, confused but still willing to do what was required to earn the promised cash. It was only when Carl began forcibly stripping him that he realised what he'd agreed to. He tried to run, tried to scream, but Carl's thick fingers closed around his throat, cutting the sound off before a soul could hear it. Carl went on choking the little boy all the way through his rape, and he was unsurprised to find the boy was dead when he finished. This time, he didn't even bother to cover the body, choosing instead to just cast it into a pile of trash like a discarded rag. It didn't matter who found little Alexander, or when. Carl would be long gone.

He continued south to Baltimore, where he planned to kick off his grand scheme with the first small step. Before he could burgle a house, he needed tools, and to fund those he planned to start out with a simple mugging, the kind of thing that he had done a thousand times before without even breaking a sweat. Things were not so simple this time around. The young man that Carl had cornered in an alleyway between the houses did not give up his money-clip when it was demanded. In fact, he lifted his hands up to fight Carl, the first time that he could even remember one of his victims doing so. That sign of resistance was all the excuse that Carl needed to unleash his fury. The pain that dogged his every step boiled up in him, desperately seeking an outlet, and Carl poured it all into that poor man, all for the terrible crime of taking too long to hand over his own money.

When his rage had abated, Carl was slick with blood and the man, little more than a teenager, was dead. Scrabbling together the rust-stained notes that had cost a man his life, Carl headed straight to the train-yard to skip town. He'd gotten what he wanted, even if it wasn't how he wanted it.

In Washington, D.C., Carl gathered himself, purchased the tools he needed, and set to work. With his crippled legs, he was much slower and distracted all the time. His temper flared constantly alongside the pain, and it was only a matter of time before the same red rage descended over him and he lost control. At the time when he needed to be at his most calm and in control, Carl was losing all mastery over his body and mind. A string of clumsy burglaries swept through Washington, and it was only pure luck that Carl didn't come face to face with any of the owners of the properties that he was robbing. If he had, they would have died, there was no question of it. Eventually, he was spotted heaving himself through the window of a popular dentist, and the police picked him up as he was leaving with some jewellery and a radio tucked under one arm. He tried to fight them, but a few blows to his legs with their night-sticks were enough to put an end to any fight that he had left in him.

He was processed swiftly and dumped into the D.C. jail to await trial. His usual menacing approach was undercut severely by his inability to even walk without holding onto his cell bars, and when he started chipping away at the mortar around his cell-window in the middle of the night, one of the neighbouring prisoners found enough courage to report his escape attempt to the guards. Carl was hauled down to what he assumed would be solitary confinement but soon turned out to be a yard with a snorting pole set into the concrete floor. He scoffed at it. He'd taken a hundred beatings in his life and all that they had ever done was make him tougher. What did these guards think they could do to him that hadn't been done worse before? His opinion on that changed rapidly when they hoisted him up onto his tip-toes by his handcuffed wrists. Stretched out like that, it was like

all the pain that was usually trapped inside his ruined bones was being set free. His legs, back and ankles felt like they were on fire at the best of times, but now they were an inferno that threatened to consume him. Carl screamed until he was hoarse. Then, in a ruined and ragged voice, he began cursing every one of the guards, and his own parents for birthing him. This soon escalated into threats of violence and murder that the guards laughed off until Carl started detailing what he would do to their children when he escaped. He described exactly how he would abduct them, rape them and choke the life out of them with his bare hands, the same way he had so many little boys before. Carl was delirious with the pain, but the details that he provided were so painfully specific that the guards were spooked. Working together, the guards clubbed him unconscious before he could say any more. They then went to find some of the police on site to report what had been said and jump-start a far larger investigation than Carl had ever been subjected to before.

A few simple exploratory letters soon connected Carl to all of his various aliases and the jail time that he was still due to serve in various states, but the child murders were what really interested the Washington police. The witnesses from Salem came down and identified Carl as the distinctive, hulking man whom they had seen with George McMahon before he died. Another witness from Philadelphia identified him as the killer of Alexander Uszacke but was unwilling to give testimony in court after looking into Carl's eyes and understanding all too clearly what would happen to him if he gave evidence against him. The one murder was sufficient for the purposes of the Washington police. Carl was given a sentence of life without parole, and with every expectation that many additional trials would be required over the coming months as Carl's connections to other crimes could be corroborated. Regardless of whether they could get any other charges to stick, the simple truth was that Carl would never be a free man again. From the moment of his conviction for the murder of George McMahon, any hope of a life outside was over.

There was considerable debate about which prison would be best to hold the man who had escaped so many, and Carl's history of incarceration under all of his many names was considered by lawyers on both sides before finally it was agreed that he should serve out his time at Leavenworth Federal Penitentiary in Kansas, just a short distance from Fort Leavenworth, where he had served his first adult sentence. There was nothing particularly special about the prison at the time—it wasn't one of the most hellish nightmares that prisoners could expect to be cast into, especially not when it was compared to some of the places that Carl had been. But, it was conveniently located close to many of the states that still had ongoing litigation against Carl, and there was a suspicion that a slightly more relaxed atmosphere might prevent Carl from making his usual escape attempts.

In truth, Carl could've easily escaped from the prison, just as he had so many before, but he lost the impetus to do so. All of the loathing that he felt for the human race had finally been turned inwards. The pain that he was living with and the memories of those brief moments in his life where he thought that he might be able to live like a normal man were haunting him now, and with each passing day, the dull, grey reality of his imprisonment became less and less real when compared to the vibrancy of his memories and his agony. He didn't want to be free anymore. He didn't want to live anymore. He had done so many terrible things in the pursuit of pleasure, and now all that he was left with was pain. Endless, constant pain.

Even his usual attempts to rule the roost in Leavenworth were subdued. He would not let anyone make him a victim, but he no longer had the energy to victimise anyone else. He stood in the mess hall on his first day and made a declaration. 'You all know who I am and what I've done. I will kill the first man that bothers me.'

It was succinct and to the point. Nobody bothered Carl. He served out his first year without making a ripple beyond several

wheedling letters to the warden regarding his job assignment. Most of the jobs on offer around the prison required the prisoners to stand for hours at a time, something that caused Carl agony with his ruined legs. Eventually, he was assigned to solitary work in the laundry room, where he could sit in a chair in peace. The only company that he received there during the long hours of folding was an hourly visit from the laundry foreman, Robert Warnke, who would make sure no mischief was going on before leaving Carl well alone.

By the end of that first year of silent introspection, Carl was done. The misery that he always turned outwards onto the world was now consuming him. The rot at his core was starting to spread.

One winter's afternoon, Robert made an extra visit to Carl's room. It was the only place in the whole building that was warm enough to be considered comfortable. Carl felt that this visit was an intrusion. He felt that the man was bothering him. As the rage descended over Carl, his old self seemed to reassert itself. He tore a copper pipe from the plumbing and strode across the room without a flinch. He clubbed Robert over the head, and then, when the man fell unconscious at his feet, he went on beating him. He clubbed Robert Warnke with that pipe until there was nothing left of the man's head and the pipe itself had warped from battering off the concrete floor. He dropped the bar at his feet and slumped to the ground, laughing. Despite everything, it seemed that the monster was still in him, just waiting beneath the surface for an excuse to come out, and this time the devil in him had delivered not just one death but two, for there could be no doubt that he would hang for murdering a guard like this.

Carl was taken directly from the laundry room to death row.

Hurry It Up

It was on death row, awaiting his trial and his execution, that Carl made the acquaintance of a guard named Henry Lesser, who would sneak him cigarettes. The first time that the men met, Henry asked Carl who he was and got the cryptic reply. 'I reform men, just like you.'

Henry was the first man in any position of power to recognise that Carl was an intelligent man underneath his mask of savagery, and the two of them soon became, if not friends, then at least confidantes. Henry was fascinated by not only Carl's little anecdotes about his life but also about the coherent nihilist philosophy that underpinned his every action. In the run-up to his latest murder trial, Carl was finally convinced, by no small amount of Lesser's flattery, to put some of his thoughts down onto paper. Over the course of the long months, with Lesser smuggling him writing materials each day, Carl wrote down a 20,000-word confession to every one of his crimes, detailing the life that he came from, his childhood and, most importantly to Lesser, the philosophy of 'might makes right' that underpinned every part of it.

It's from this document that the story in this book is predominantly drawn, and over the years, many researchers

have gone through the document attempting to debunk some of Carl's more outrageous claims only to discover that they were completely true. Indeed, the more outrageous the claim, the more likely it was that somebody at the time had kept some record of the events.

The trial for the murder of Robert Warnke on 14th April 1929, was a brief affair that was well-attended by the press. Carl pleaded not guilty to the charge, demanding that the court prove his guilt if they wanted him to hang. With innumerable witnesses at the prison's disposal, this was no trouble at all. Carl refused representation from a lawyer, and he refused to make any requests for clemency. He longed for his suffering to end. He was returned to his cell on death row that same night and penned a letter to President Hoover, demanding that no delay to his execution should be brought about from the halls of politics. Mail was a common enough occurrence for death row inmates, and Carl ignored the majority of his, but one particular group always seemed to warrant a reply from him: civil rights campaigners who were trying to put an end to the death penalty. Carl responded to every single one of those letters with threats of gruesome violence. In particular, he would explain in detail the torturous murders that he would inflict on his correspondents if they did somehow rob him of his hard-earned hanging.

Meanwhile, a draft of his autobiography was doing the rounds in both academic and social circles, attracting a great deal of interest in the man. Lesser worked with some of the more generous patrons of the soft sciences to pursue a reprieve for Carl, campaigning the governor to spare him so that his potential contributions to alienism would not be lost. They claimed that, by studying Carl, they might be able to prevent more men like him from being created. It was at this point that Carl finally turned on Lesser, too, threatening all manner of violence on the man if he dared to interfere in the course of justice. He wanted to die – he wanted his pain to end – and that end could not come soon enough for him.

On 5th September 1930, Carl's big day finally arrived. He was marched out into the yard of Leavenworth into the shadow of the gallows and, for all of his flaws, he did not falter for even a moment. Even now in his final moments, he would not give anyone the satisfaction of seeing him beaten or scared. The executioner was up on the gallows, putting the final touches to the noose that would soon be wrapped around Carl's neck. They all stood in silence for a moment, then Carl broke that silence by cursing. 'Hurry it up, you Hosier bastard. I could've hung ten men in the time it took you to tie that knot.'

He strode ahead of his entourage of guards and up the steps towards the noose, brows drawn down in fury and spittle clinging to his moustache. He spat in the executioner's face and ducked his own head into the rope. When he was asked for his final words, he let loose a torrent of insults and curses against every man present, ranging from the mundane to the intensely personal. The executioner stood back, waiting for him to finish, but it soon became apparent that Carl wasn't going to finish. He was never going to finish. The wellspring of loathing that he was drawing his words from ran deep and dark, and it would never go dry. Eventually, the executioner pulled the lever, releasing the trapdoor, and snapped Carl's neck mid-word.

Attempts were made to contact Carl's family after his death, but they wanted nothing to do with him. He was consigned to a potter's field and a pauper's grave, marked only with a single plank of wood inscribed with his prisoner number: 31614.

For a time, his story still circulated in psychoanalytical circles, with some of his biggest fans among high society acquiring copies of his memoir and pouring over the gruesome details that he had relished in including. One psychologist claimed that he'd never seen a man whose destructive impulses were more fully realised and accepted as a part of the conscious mind.

For his part, Henry Lesser wanted to share Carl's story with the world. He shopped the book around to publishers for decades, trying to attract attention to the stark prose, even if the content was unpalatable to the contemporary reader. It would be decades before any publisher was willing to publish Carl's autobiography, and by then, so much of the evidence of the crimes that he'd confessed to had vanished into the mists of time, but enough of the confessions could be proven true that it is logical to believe all of them were true, or at least Carl's recollection of them. While researching criminals, it is often necessary to take whatever information they provide to you with a grain of salt as they are trying to manipulate the situation to their advantage—either by trying to make themselves sound tougher than they are or by making themselves sound more innocent so that they might avoid further punishment. In Carl's case, there is no need for doubt. He had nothing to lose when the time came for him to put pen to paper. He was already a dead man. More importantly, the horrific details that he included within his testimony would have been excised by any normal psychopath trying to maintain their credibility.

Carl had no shame about what he was, even if it did cause him some conflict throughout his life. Even when he longed to be different, he never denied the truth about himself. Carl knew that he was a monster. He revelled in punishing the human race for their slights against him, but at least he was an honest monster. His passions were rape, murder and alcohol, and he pursued those passions with as much vigour as was possible for him at any given moment.

Compared to a modern serial killer, Carl seems far simpler. A product of a harder time and harsh punishments. Yet, there were hundreds of men imprisoned right alongside Carl who never became the monster that he was. There were thousands who lived through the same horrifying childhoods. Deep inside Carl there was a seed of darkness that blossomed through his torments, something absent from normal men who merely broke

when confronted with such insurmountable pain. It was that darkness that gave him his incredible strength, his incredible resolve and his death-wish. Carl Panzram hated like nobody else, and while that hatred eventually turned against him and drove him to an early grave, it was a force to be reckoned with until the very last moment of his life.

RYAN GREEN

Want More?

Did you enjoy *Kill 'Em All* and want some more True Crime?

YOUR FREE BOOK IS WAITING

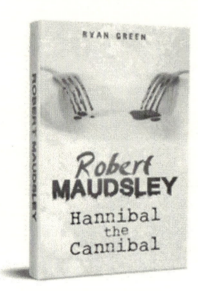

From bestselling author Ryan Green

There is a man who is officially classed as **"Britain's most dangerous prisoner"**

The man's name is Robert Maudsley, and his crimes earned him the nickname **"Hannibal the Cannibal"**

This free book is an exploration of his story...

★★★★★ *"Ryan brings the horrifying details to life. I can't wait to read more by this author!"*

Get a free copy of **Robert Maudsley: Hannibal the Cannibal** when you sign up to join my Reader's Group.

www.ryangreenbooks.com/free-book

Every Review Helps

If you enjoyed the book and have a moment to spare, I would really appreciate a short review on Amazon. Your help in spreading the word is gratefully received and reviews make a huge difference to helping new readers find me. Without reviewers, us self-published authors would have a hard time!

Type in your link below to be taken straight to my book review page.

US	geni.us/killemUS
UK	geni.us/killemUK
Australia	geni.us/killemAUS
Canada	geni.us/killemCA

Thank you! I can't wait to read your thoughts.

About Ryan Green

Ryan Green is a true crime author who lives in Herefordshire, England with his wife, three children, and two dogs. Outside of writing and spending time with his family, Ryan enjoys walking, reading and windsurfing.

Ryan is fascinated with History, Psychology and True Crime. In 2015, he finally started researching and writing his own work and at the end of the year, he released his first book on Britain's most notorious serial killer, Harold Shipman.

He has since written several books on lesser-known subjects, and taken the unique approach of writing from the killer's perspective. He narrates some of the most chilling scenes you'll encounter in the True Crime genre.

You can sign up to Ryan's newsletter to receive a free book, updates, and the latest releases at:

WWW.RYANGREENBOOKS.COM

More Books by Ryan Green

In July 1965, teenagers Sylvia and Jenny Likens were left in the temporary care of Gertrude Baniszewski, a middle-aged single mother and her seven children.

The Baniszewski household was overrun with children. There were few rules and ample freedom. Sadly, the environment created a dangerous hierarchy of social Darwinism where the strong preyed on the weak.

What transpired in the following three months was both riveting and chilling. The case shocked the entire nation and would later be described as "The single worst crime perpetuated against an individual in Indiana's history".

More Books by Ryan Green

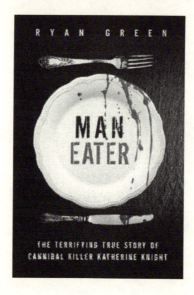

On 29th February 2000, John Price took out a restraining order against his girlfriend, Katherine Knight. Later that day, he told his co-workers that she had stabbed him and if he were ever to go missing, it was because Knight had killed him.

The next day, Price didn't show up for work.

A co-worker was sent to check on him. They found a bloody handprint by the front door and they immediately contacted the police. The local police force was not prepared for the chilling scene they were about to encounter.

Price's body was found in a chair, legs crossed, with a bottle of lemonade under his arm. He'd been decapitated and skinned. The "skin-suit" was hanging from a meat hook in the living room and his head was found in the kitchen, in a pot of vegetables that was still warm. There were two plates on the dining table, each had the name of one of Price's children on it. She was attempting to serve his body parts to his children.

More Books by Ryan Green

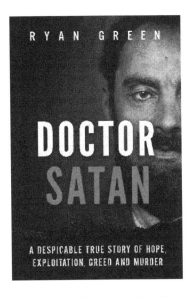

In 1944, as the Nazis occupied Paris, the French Police and Fire Brigade were called to investigate a vile-smelling smoke pouring out from a Parisian home. Inside, they were confronted with a scene from a nightmare. They found a factory line of bodies and multiple furnaces stocked with human remains.

When questioned, Dr. Petiot claimed that he was a part of the Resistance and the bodies they discovered belonged to Nazi collaborators that he killed for the cause. The French Police, resentful of Nazi occupation and confused by a rational alternative, allowed him to leave.

Was the respected Doctor a clandestine hero fighting for national liberty or a deviant using dire domestic circumstances to his advantage? One thing is for certain, the Police and the Nazis both wanted to get their hands on Dr. Marcel Petiot to find out the truth.

More Books by Ryan Green

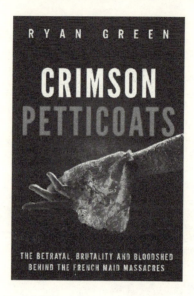

In 1861, the police of a rural French village tore their way into the woodside home of Martin Dumollard. Inside, they found chaos. Paths had been carved through mounds of bloodstained clothing, reaching as high as the ceiling in some places.

The officers assumed that the mysterious maid-robber had killed one woman but failed in his other attempts. Yet, it was becoming sickeningly clear that there was a vast gulf between the crimes they were aware of and the ones that had truly been committed.

Would Dumollard's wife expose his dark secret or was she inextricably linked to the atrocities? Whatever the circumstances, everyone was desperate to discover whether the bloody garments belonged to some of the 648 missing women.

Free True Crime Audiobook

Sign up to Audible and use your free credit to download this collection of twelve books. If you cancel within 30 days, there's no charge!

WWW.RYANGREENBOOKS.COM/FREE-AUDIOBOOK

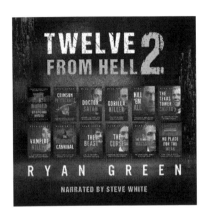

"Ryan Green has produced another excellent book and belongs at the top with true crime writers such as M. William Phelps, Gregg Olsen and Ann Rule" –**B.S. Reid**

"Wow! Chilling, shocking and totally riveting! I'm not going to sleep well after listening to this but the narration was fantastic. Crazy story but highly recommend for any true crime lover!" –**Mandy**

"Torture Mom by Ryan Green left me pretty speechless. The fact that it's a true story is just…wow" –**JStep**

"Graphic, upsetting, but superbly read and written" –**Ray C**

WWW.RYANGREENBOOKS.COM/FREE-AUDIOBOOK

Made in the USA
Columbia, SC
22 April 2025